LONDON

A MODERN CITY IN PHOTOGRAPHS

MATHEW BROWNE

AMBERLEY

First published 2023

Amberley Publishing
The Hill, Stroud
Gloucestershire, GL5 4EP

www.amberley-books.com

Copyright © Mathew Browne, 2023

The right of Mathew Browne to be identified as the Author of this work has been
asserted in accordance with the Copyrights, Designs and Patents Act 1988.

ISBN 978 1 4456 9396 5 (print)
ISBN 978 1 4456 9397 2 (ebook)

British Library Cataloguing in Publication Data.
A catalogue record for this book is available from the British Library.

Typesetting by SJmagic DESIGN SERVICES, India.
Printed in the UK.

ACKNOWLEDGEMENTS

As with my first book I must thank my wife Louise for caring for our son George during my trips away, and her support while I pursued this project.

I discovered that photographing in London could be a logistical headache, sometimes mired in health and safety permission slips, email threads that go cold and other office bureaucracy; often this was counterbalanced by friendly security and admin staff who gave me the green light to shoot on their premises, to whom I am indebted. I must especially thank the following custodians, designers, architects, artists, managers and landowners for their approval to share these images with you: Emily Wright and the Royal Parks, Wembley Stadium, Tim Pollard and Arsenal Football Club, Jo Edwards and TSBA Group, Transport For London, Natural History Museum Picture Library, Luke Jerram, East Sheen Library, Janine Stanford and Richmond and Wandsworth Councils, Sue Edkins, Mortlake with East Sheen Society, Heathrow Airport, British Airways, Flybe, Liz West, Jodi Meadows at Paddington Central, Freya Berry and the Science Museum, Zaha Hadid Architects, Ayesha Kapila and Heatherwick Studios, Thomas Watts and Channel 4, Mandy Pursey and John Lewis & Partners, Chris Meehan and Dorsett Hotels, Adriana Fiedler and the Environment Agency, James Cochran, Georgina Sheehan and Royal Museums Greenwich, Bold Tendencies, Leake Street Arches, Citizen M Hotels, The Shard, Open House London, Lesley Johnson and Canary Wharf Group, London City Airport, Charlotte Booth and The Line, Akmol Hussain and Centre of the Cell, Aloft Hotels, Ante and Sam Sure LTD, Saba Park Services, Queen Elizabeth Olympic Park, The British Library, Network Rail, One New Change, Greater London Authority, Cartier, Stella McCartney, Allen & Overy, Daunt Books, Premier Inn, Wellcome Collection, Renaissance Hotels, City of London, Sky Garden, 120 Fenchurch Street, Location House.

This book features several artworks by James Cochran (www.akajimmyc.com)

Facebook @Jimmyc.artwork
Instagram & Twitter @akajimmyc

Boris Johnson clown artwork by Ante and Sam Sure Ltd
Instagram @ante_ltd

I'd also like to thank the following people who have provided assistance along the way: Claire and Tom Broomhall, Pippa Brown, Joe Becker, Georgie Bellan, the team at Carmarthen Cameras and my business partners at PhotoHound – Luka Esenko, Julie Renahan and Anton Averin.

My profound thanks to my employers at Skylum Software whose support during the pandemic kept me afloat.

Once again I am pleased to work with the team at Amberley on another photography book. I've enjoyed this challenge, and I'm proud of the work you've given me an opportunity to showcase.

Finally, to you holding this book in your hands. The Covid-19 pandemic began as I was wrapping up shooting for this book. It swept away my schedule, my bookings and, at times, my hope that a career in photography could remain viable. As we emerge on the other side of the pandemic I'm evermore grateful to anyone that supports my artwork, be it in the form of a book, a print, a workshop or simply sharing my work to a wider audience on social media.

INTRODUCTION

Though I'm a proud Welshman – I live about three hours west in Carmarthen – London is a city I'm deeply fond of. I studied at University College London, it's where I got my first job, it's where I met my wife, it's where we shared our first home, and it's where I proposed. So many of my formative experiences as a young adult were here. Now – a little bit older and a little bit heavier, but probably not *that* much wiser – I enjoy returning with my wife and our son.

It was only after leaving London that my interest in photography stirred, so I return to the city now as though visiting for the first time, seeing the city through the eyes of a photographer and visiting all the tourist traps that resident Londoners might cynically avoid.

We left our Docklands home in 2008 as the vast Olympic regeneration plans took shape. The next time we returned, great swathes of the city were barely recognisable, such as the DLR extensions and myriad residential developments popping up, the Queen Elizabeth Olympic Park and Stratford's vast new residential and retail complexes. In fact, *every* time we return so much has changed.

This book is subtitled *Modern City in Photographs* as I wanted to capture the perspectives and juxtapositions that show London as a city in this constant state of renewal, in the form of architecture and artworks that transformed London's public spaces in the twenty-first century.

Unintentionally though, this book also serves in places as a snapshot of London on the cusp of succumbing to the Covid-19 pandemic. I'd allowed eighteen months to capture my images, from January 2019 to June 2020. I hadn't anticipated that my final visit would be in February 2020, as reports of a respiratory virus were gathering pace but not causing too much panic yet.

That day I'd set aside a morning to capture the arrivals at Heathrow Airport, during which I took two photographs, presented in this book, that represent a bit of aviation consigned to history. First, the arrival of one of the final Flybe flights before the airline collapsed, and a shot of a British Airways 747 – the 'queen of the skies' – not long before the airline retired its fleet.

I like to capture a sense of solitude in my images, such as a deserted Piccadilly Circus in the early morning blue hour. Of course, such scenes would become commonplace months later as lockdown measures meant much of the capital became a ghost town.

I adhered strictly to Covid-19 guidance, meaning I wasn't able to resume shooting for several months. When I did, though hand sanitiser and face masks were ubiquitous, little else had changed. Cranes still arc across the sky, buildings are still going up, scaffolding is still coming down, and the Northern line is always rammed at rush hour.

Though much of what you see in this book is liable to be obsolete in a decade or two, I hope you enjoy my photographic study of London as it stands today. It is my love letter to a city I hold dear and owe so much to, that I've rediscovered through the lens of my camera.

PHOTOGRAPHING LONDON

All of the locations photographed in this book (and hundreds more around the city) can be found on PhotoHound (www.photohound.co), the photo location discovery website and app that I cofounded with three other intrepid photographers. If you'd like to visit these places with your own camera, here you'll find all the information you'll need for a successful shoot, such as: directions, recommended time to visit, opening hours, website, a selection of images and their EXIF data – if it's useful to visiting photographers, the information is waiting for you. You're also welcome to contribute your own images for the community to enjoy.

CENTRAL

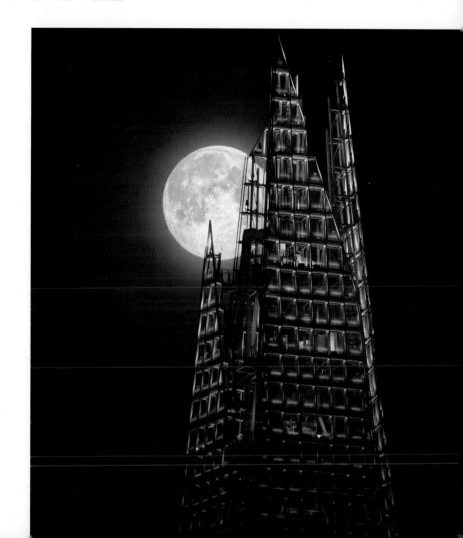

Full moon behind The Shard

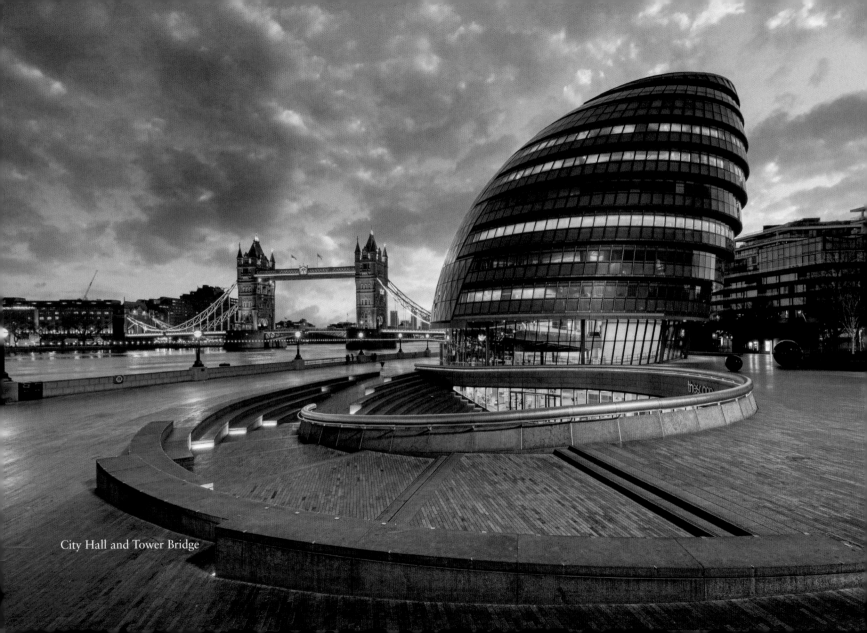
City Hall and Tower Bridge

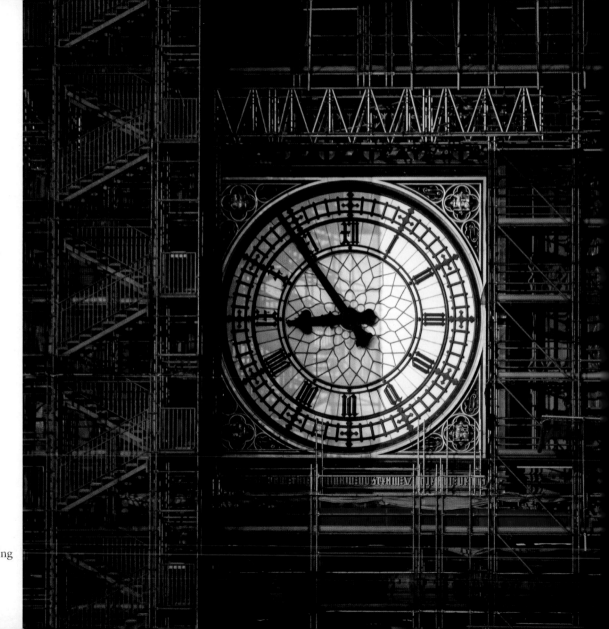

Elizabeth Tower cloaked in scaffolding

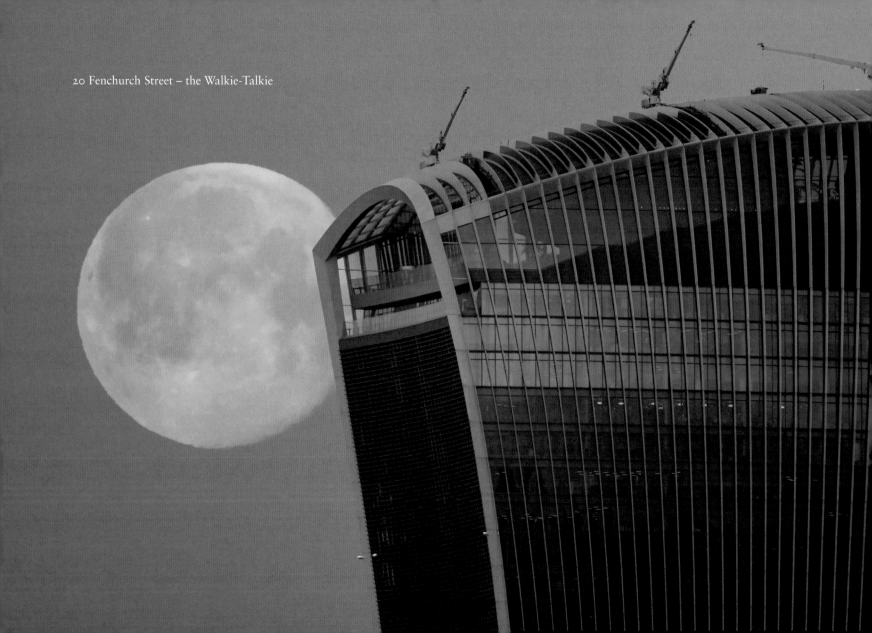

20 Fenchurch Street – the Walkie-Talkie

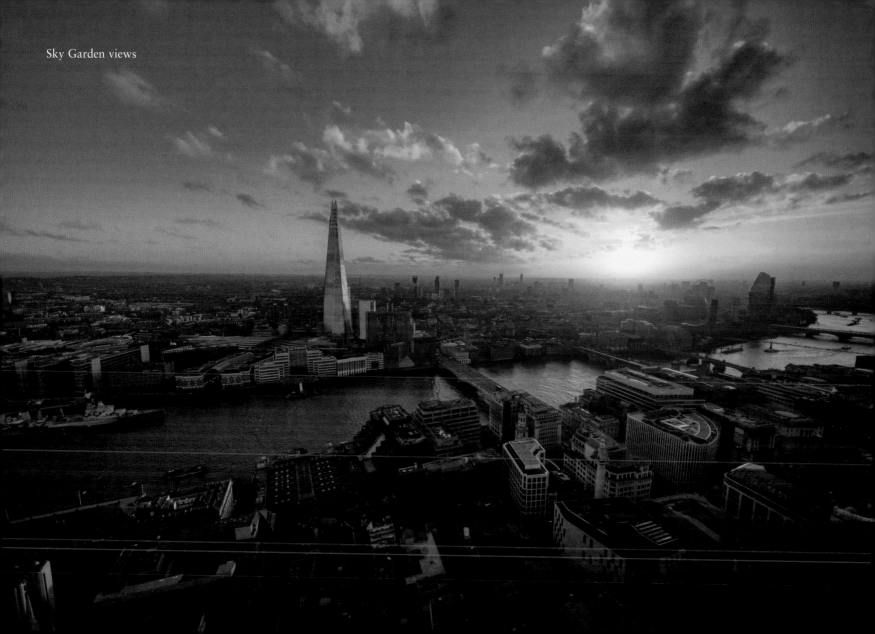

Sky Garden views

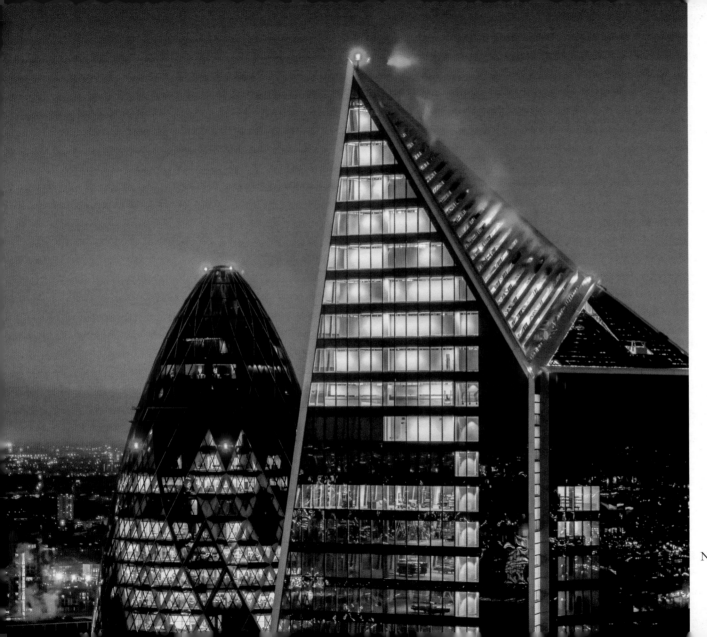

Neighbouring skyscrapers

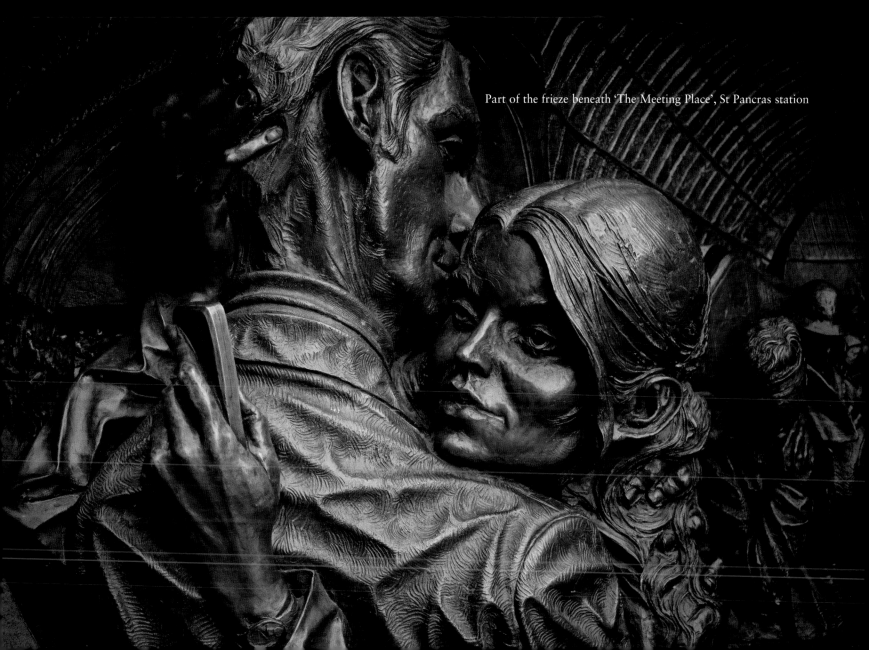

Part of the frieze beneath 'The Meeting Place', St Pancras station

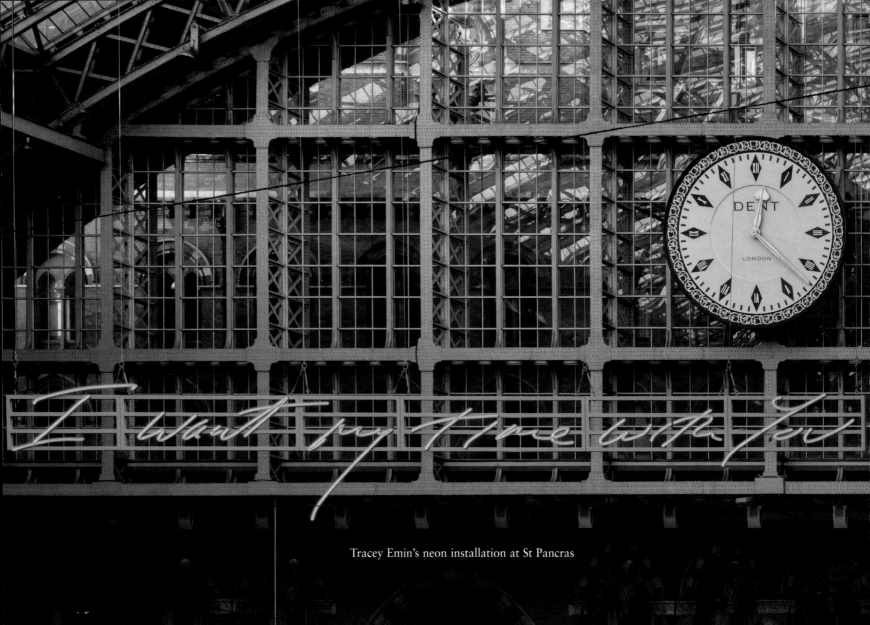

Tracey Emin's neon installation at St Pancras

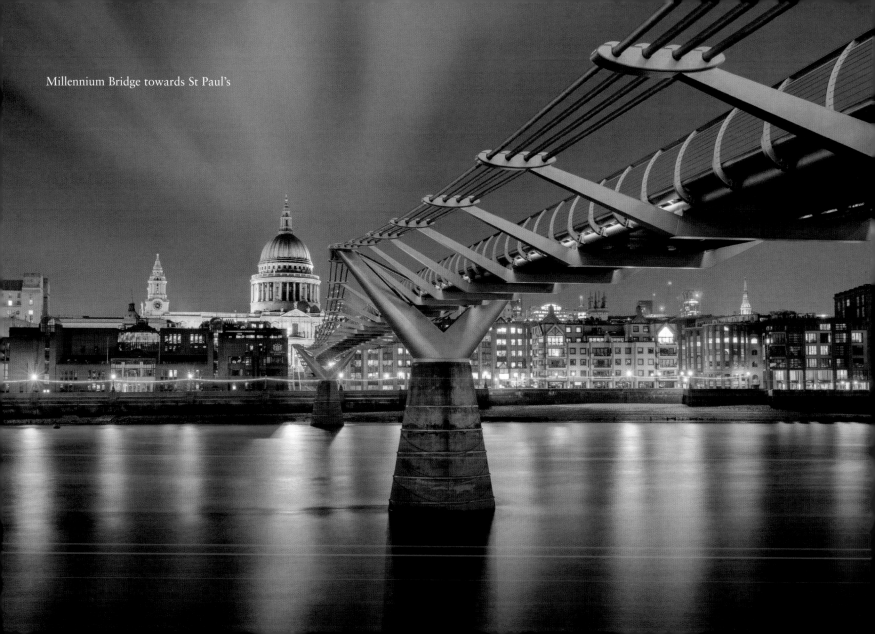

Millennium Bridge towards St Paul's

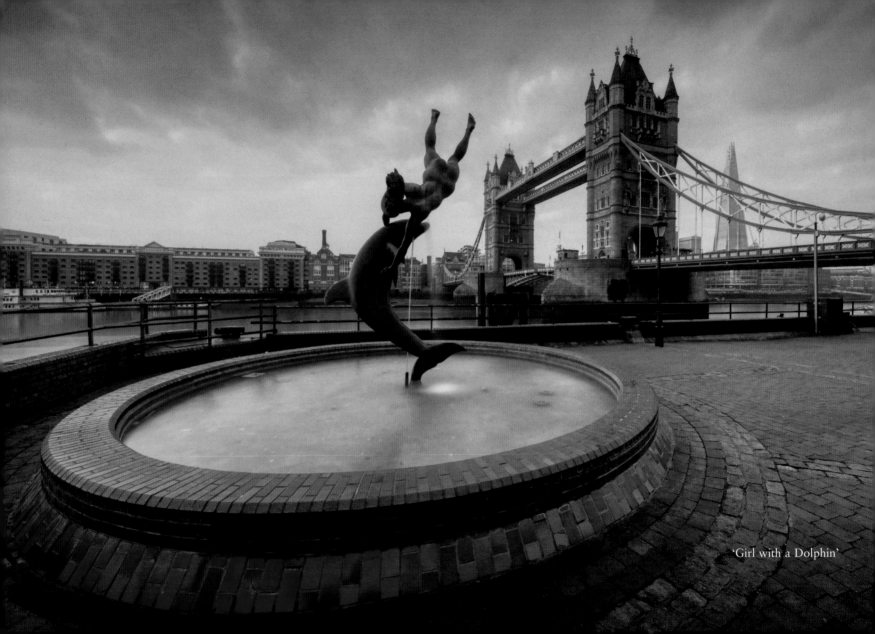

'Girl with a Dolphin'

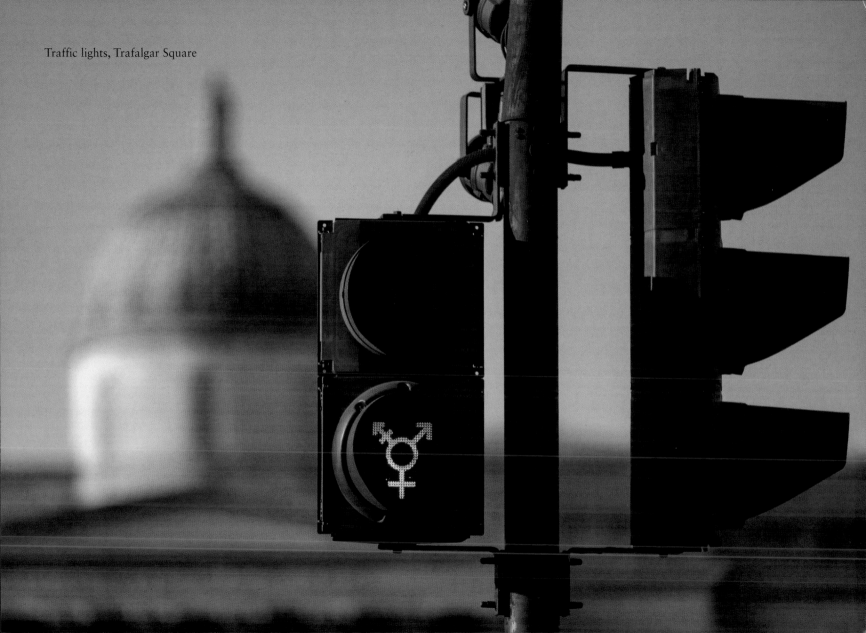

Traffic lights, Trafalgar Square

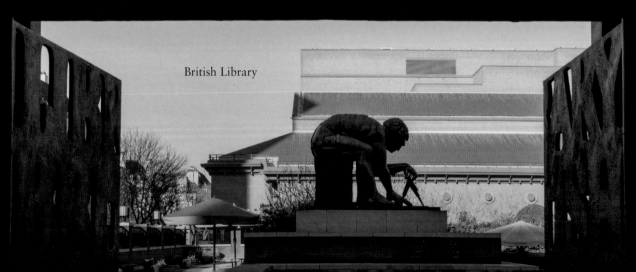

British Library

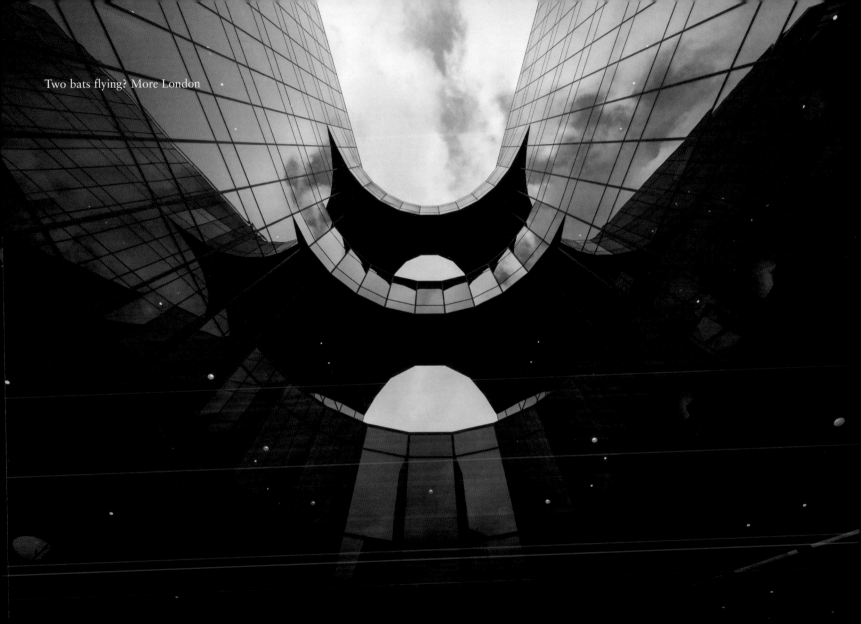

Two bats flying? More London

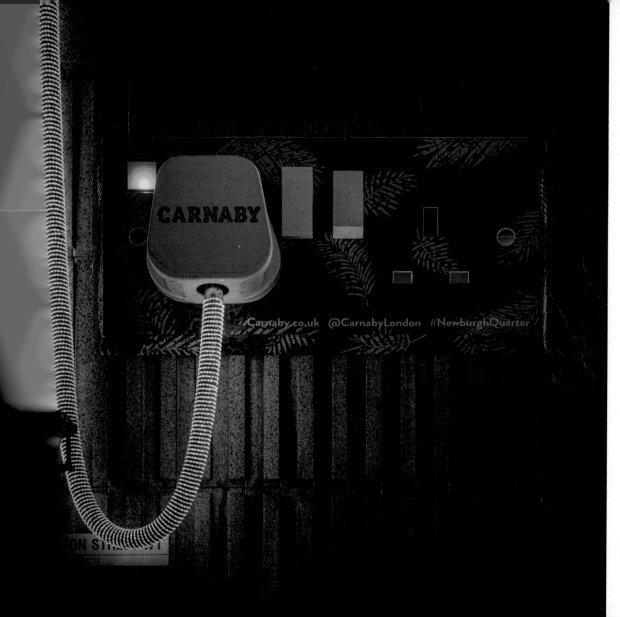

Carnaby Plug – perhaps this plug keeps Carnaby Street's lights on

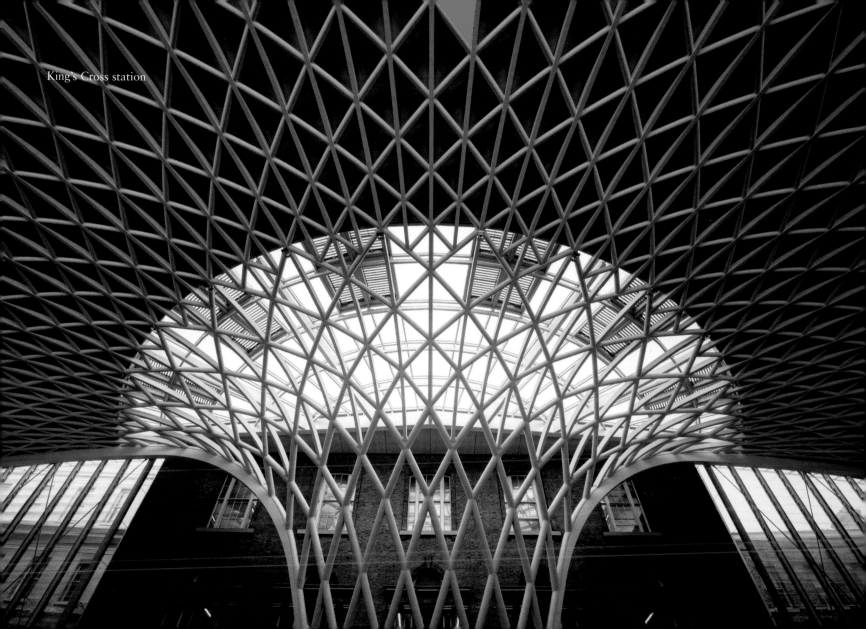

King's Cross station

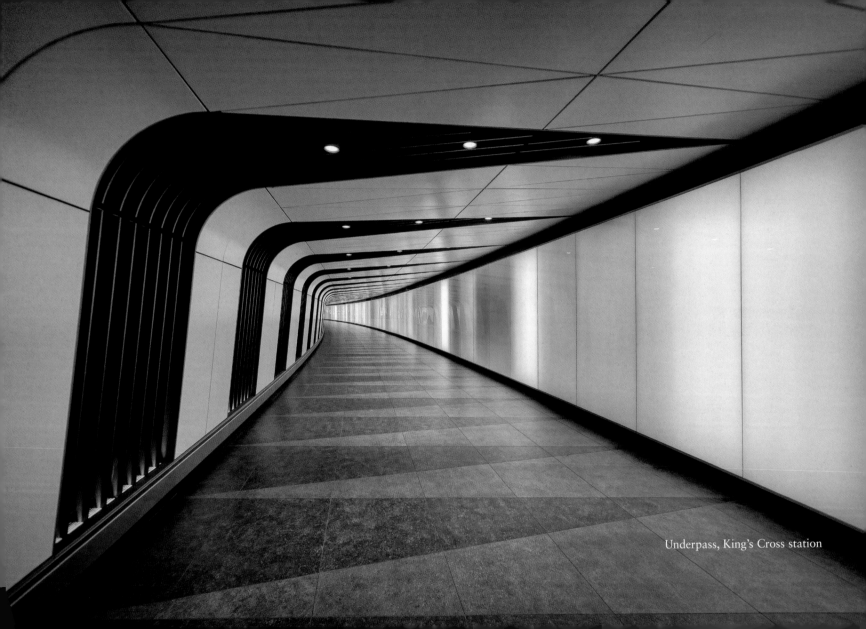

Underpass, King's Cross station

Open House London, Bishops Square

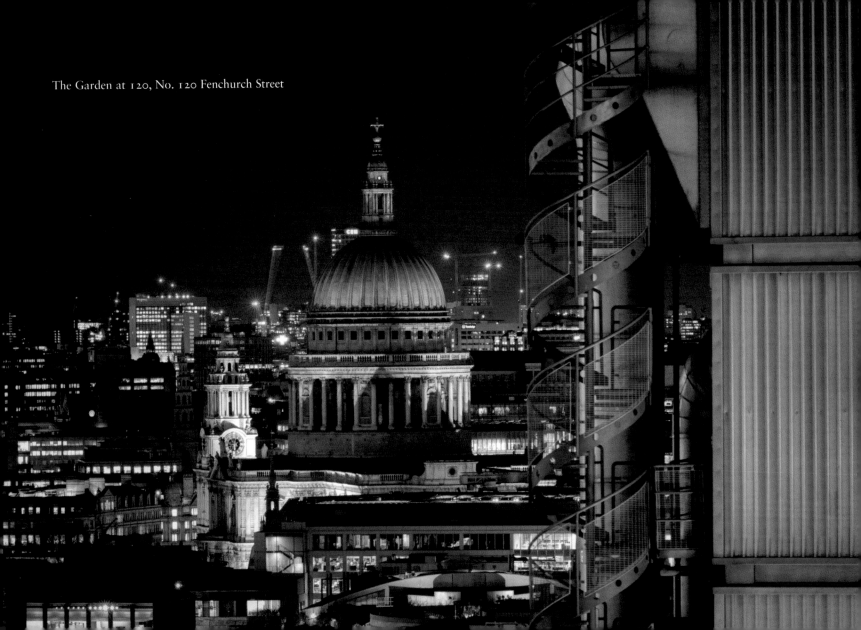

The Garden at 120, No. 120 Fenchurch Street

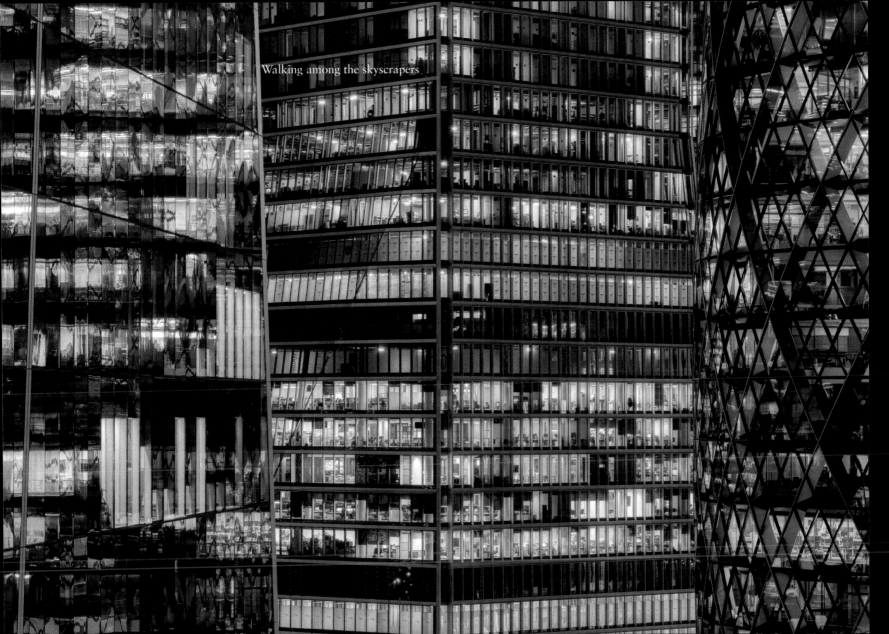
Walking among the skyscrapers

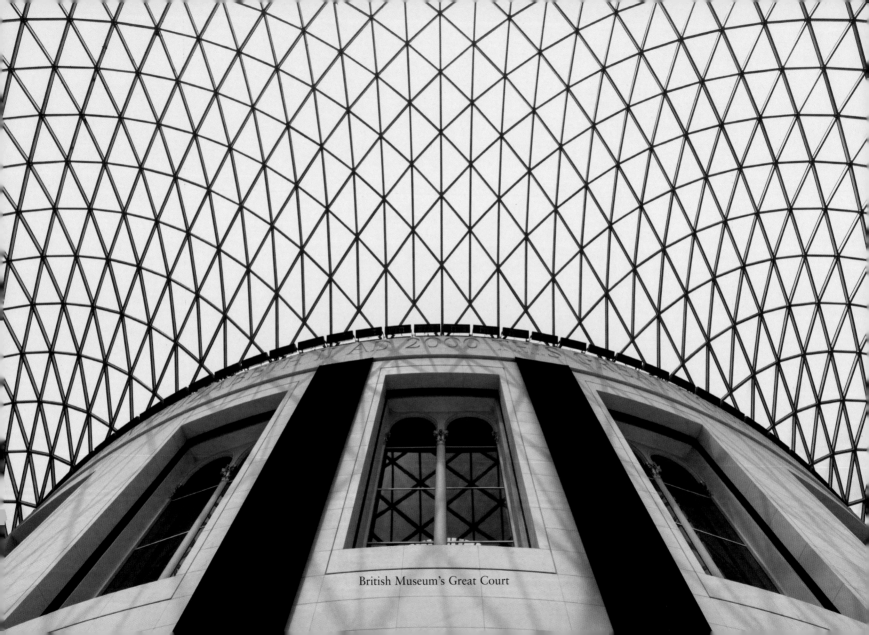

British Museum's Great Court

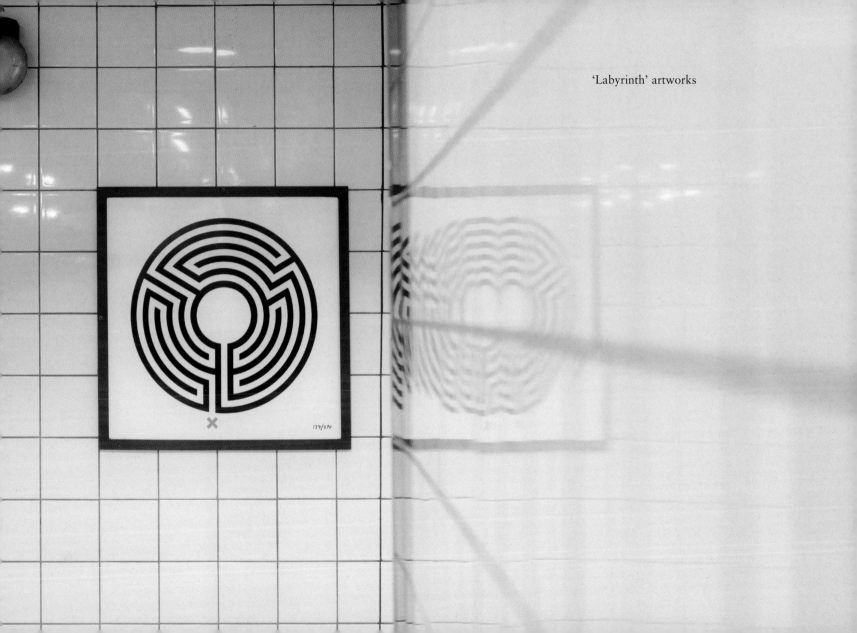

'Labyrinth' artworks

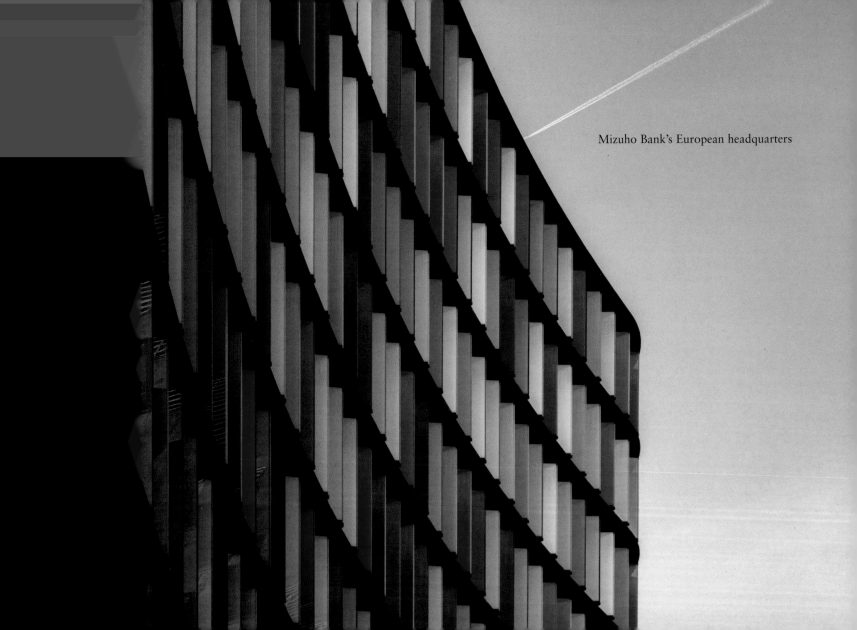

Mizuho Bank's European headquarters

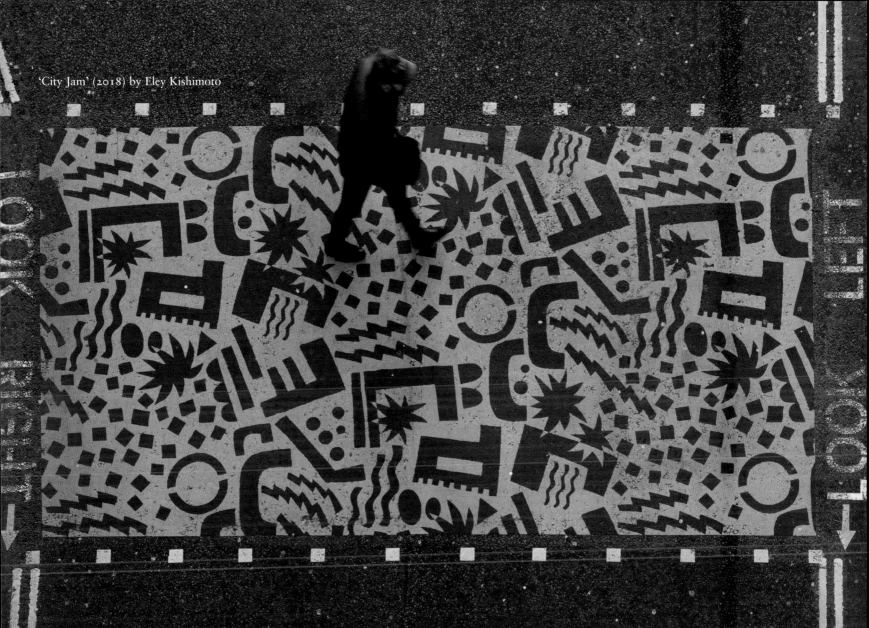

'City Jam' (2018) by Eley Kishimoto

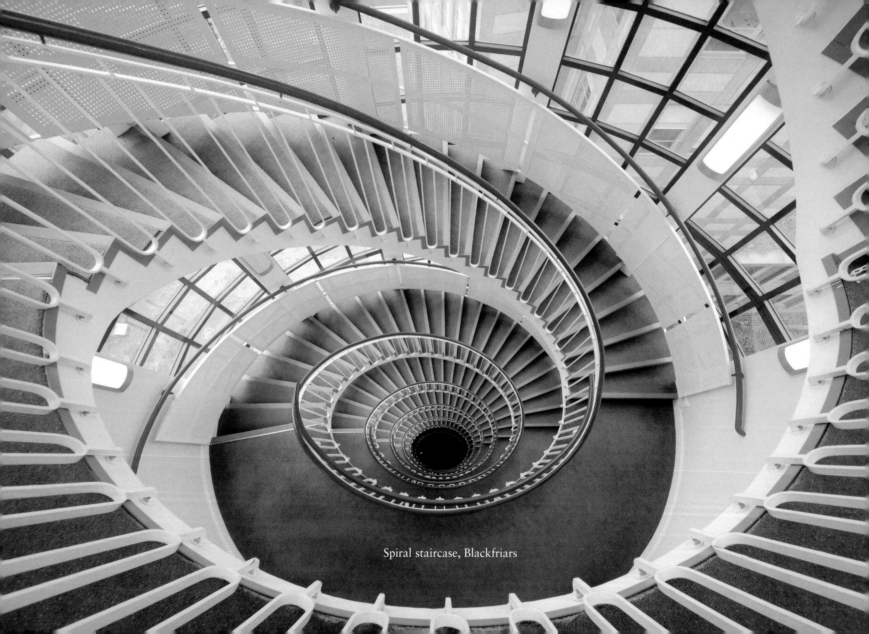

Spiral staircase, Blackfriars

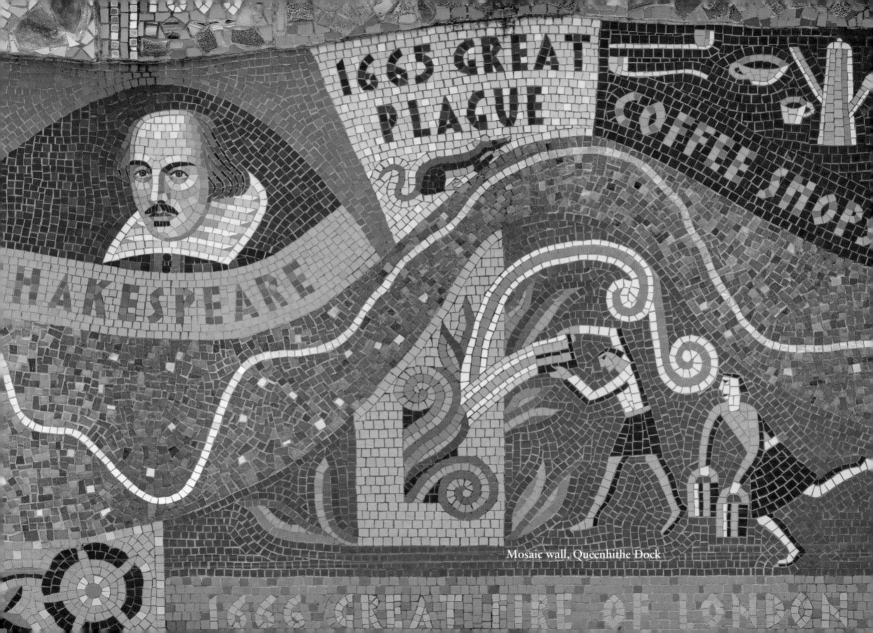

1665 GREAT PLAGUE

COFFEE SHOP

SHAKESPEARE

Mosaic wall, Queenhithe Dock

1666 GREAT FIRE OF LONDON

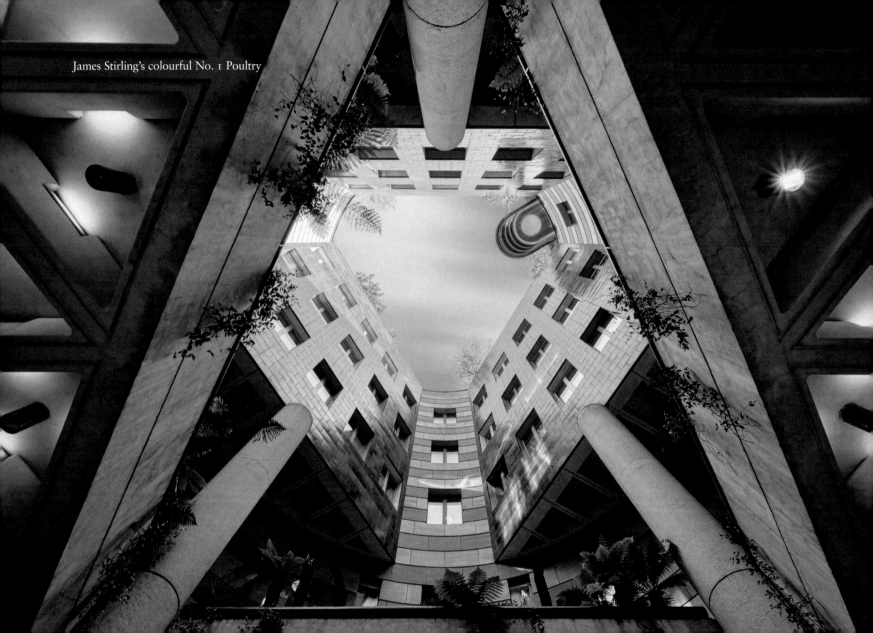

James Stirling's colourful No. 1 Poultry

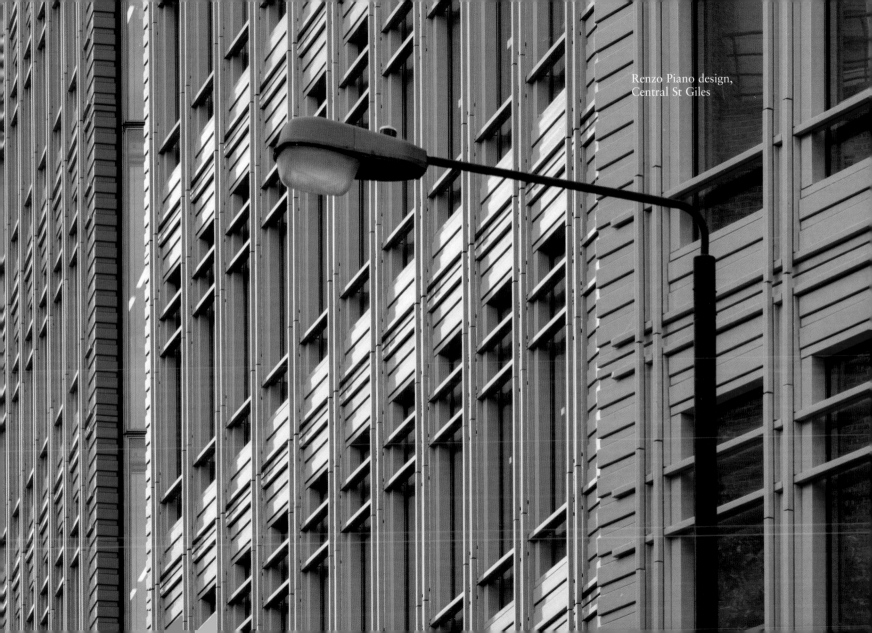

Renzo Piano design,
Central St Giles

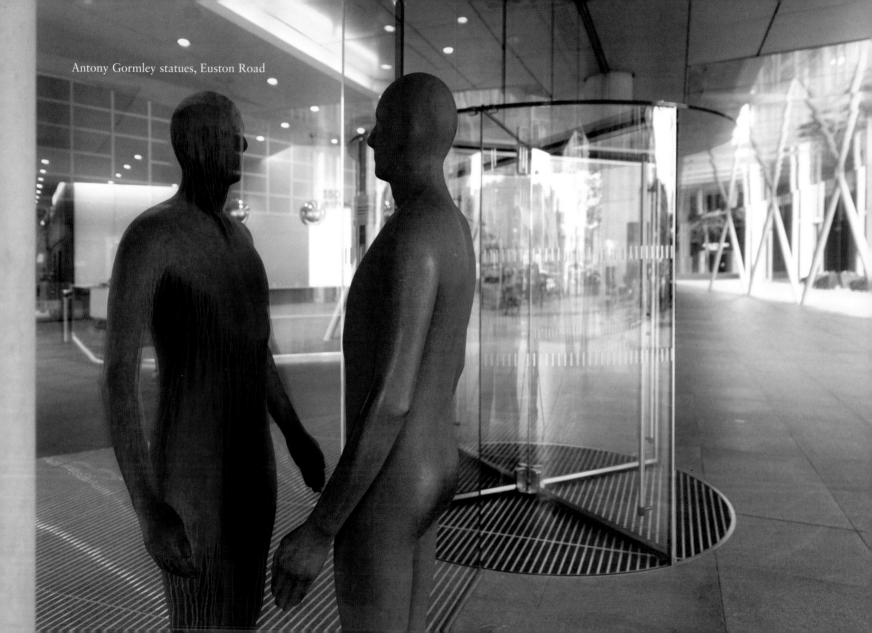
Antony Gormley statues, Euston Road

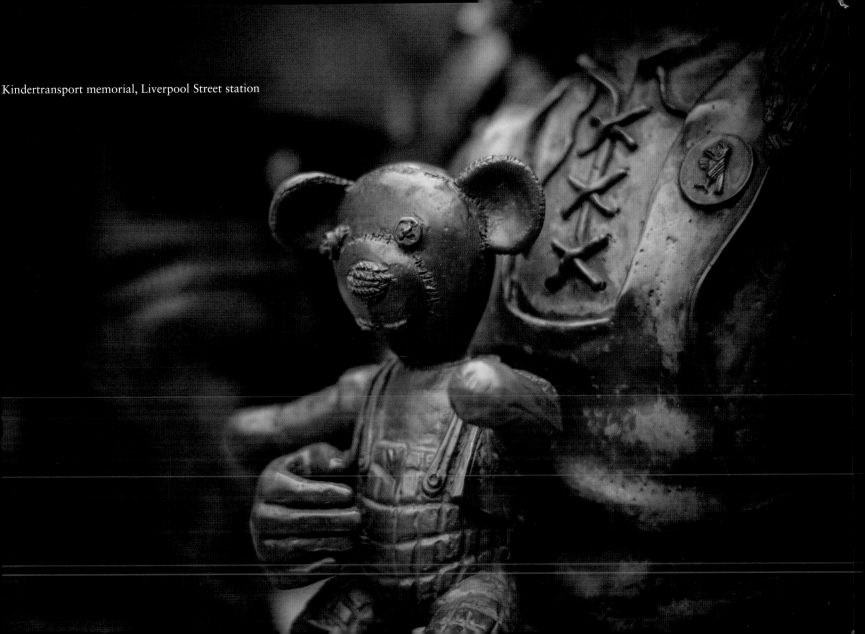

Kindertransport memorial, Liverpool Street station

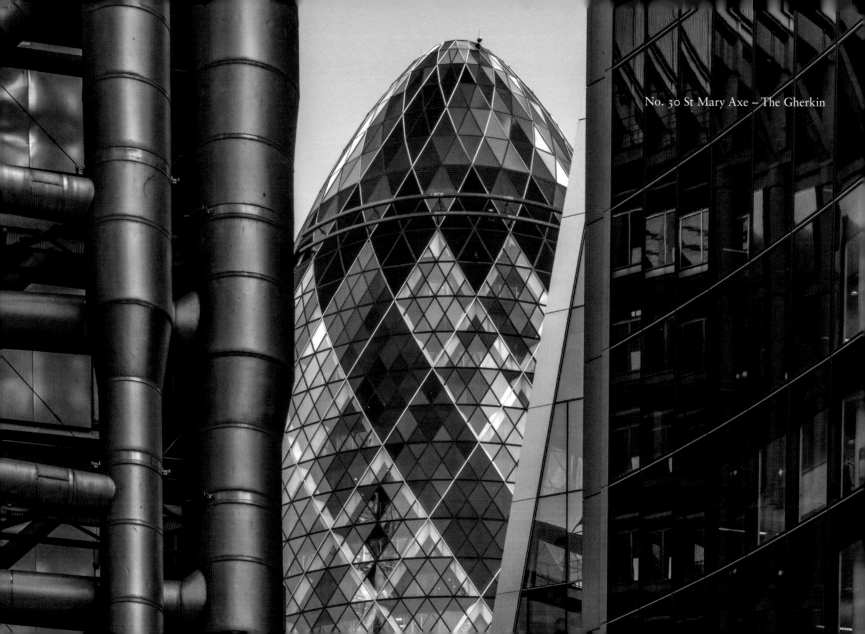

No. 30 St Mary Axe – The Gherkin

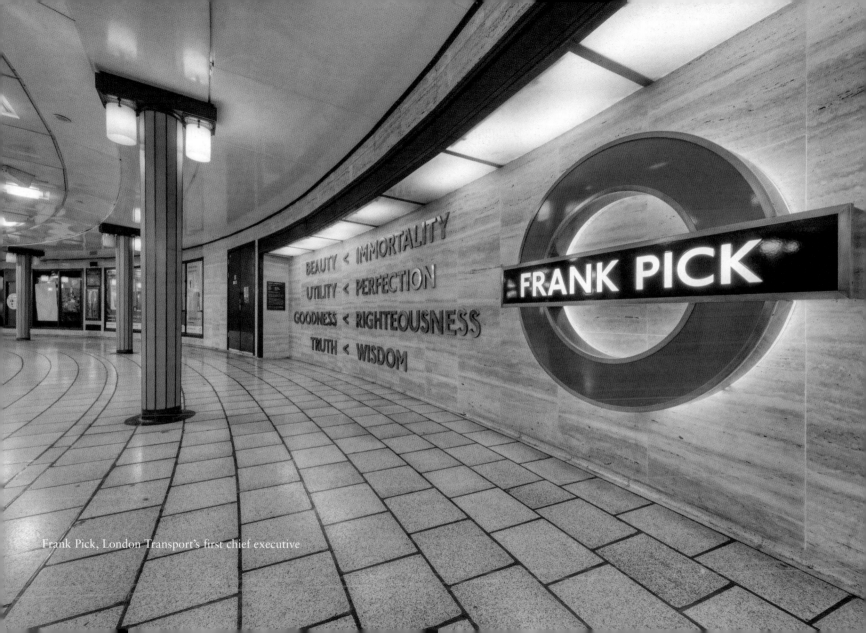

BEAUTY < IMMORTALITY

UTILITY < PERFECTION

GOODNESS < RIGHTEOUSNESS

TRUTH < WISDOM

FRANK PICK

Frank Pick, London Transport's first chief executive

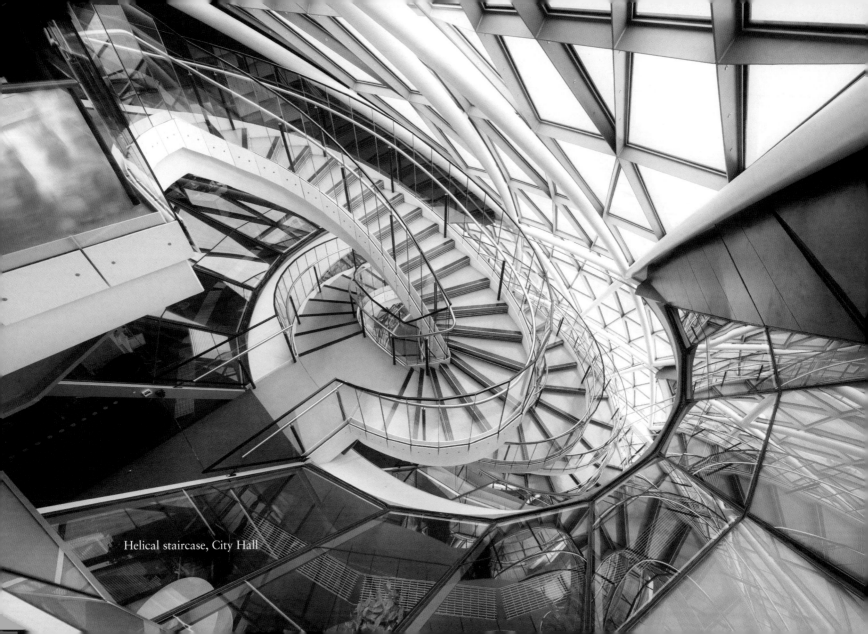

Helical staircase, City Hall

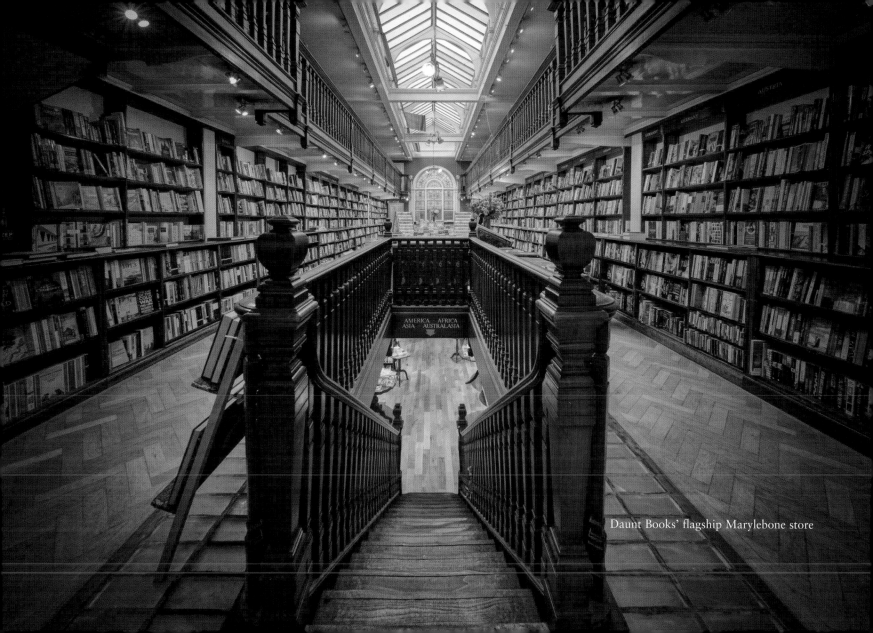

Daunt Books' flagship Marylebone store

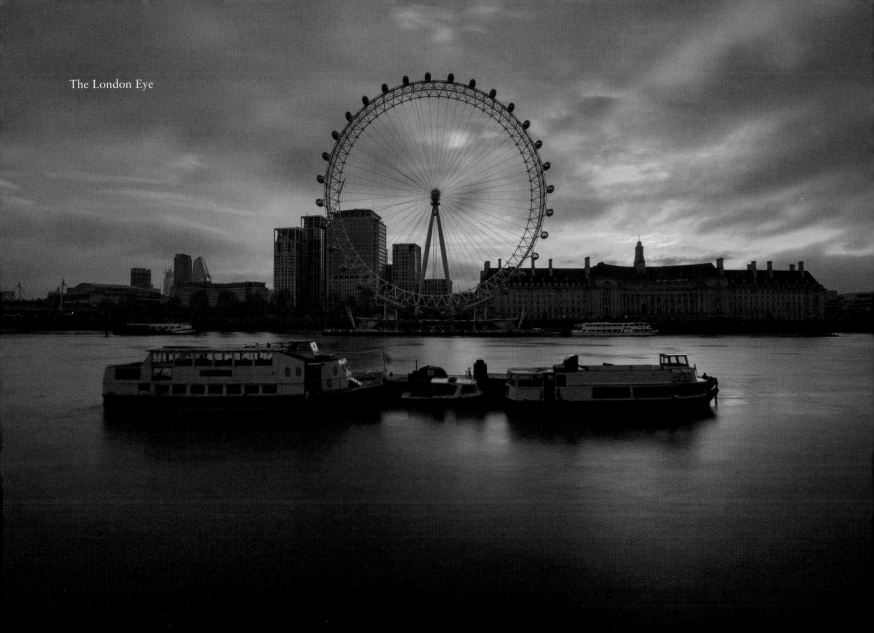

The London Eye

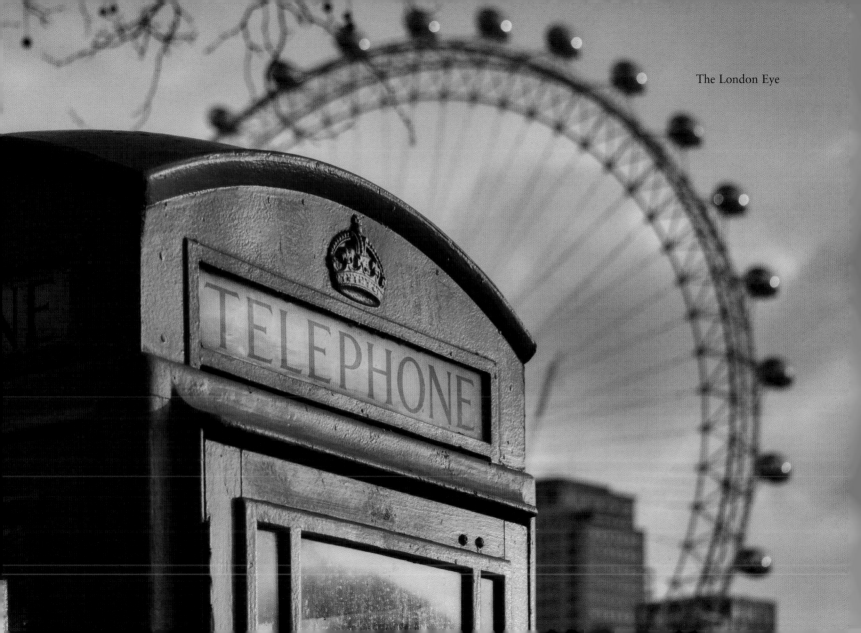

The London Eye

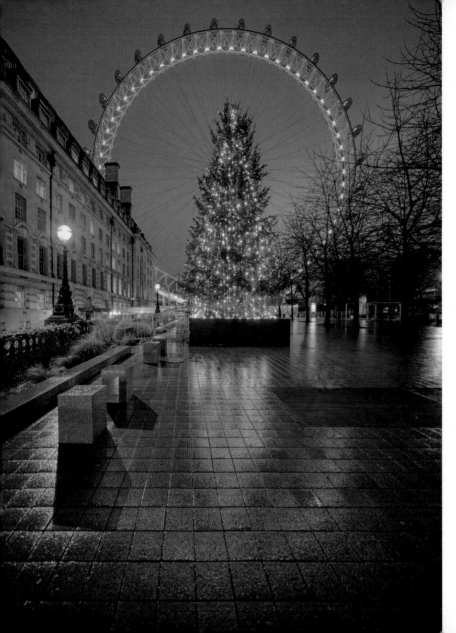

The London Eye

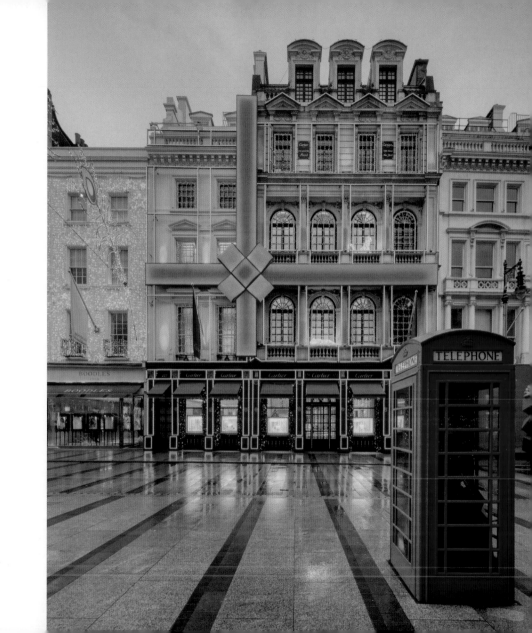

Cartier's grand Christmas display, Bond Street

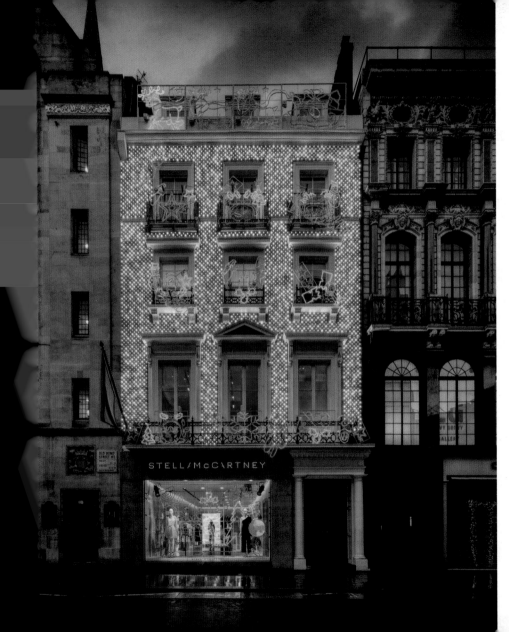

Stella McCartney, Bond Street

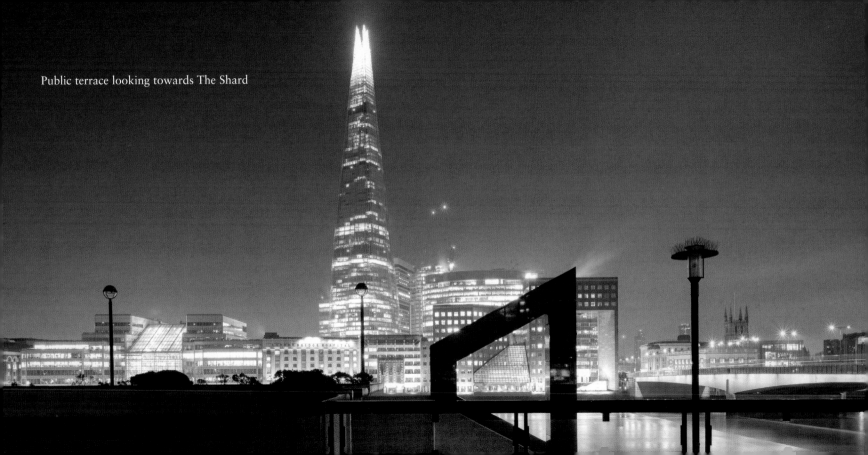

Public terrace looking towards The Shard

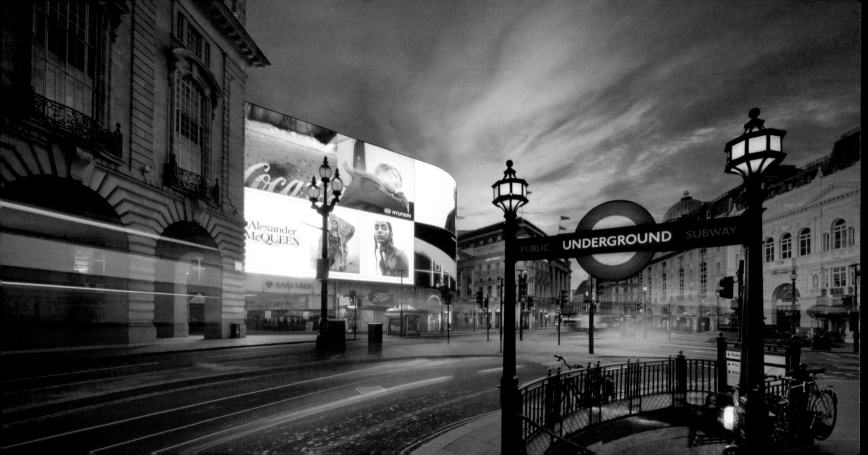

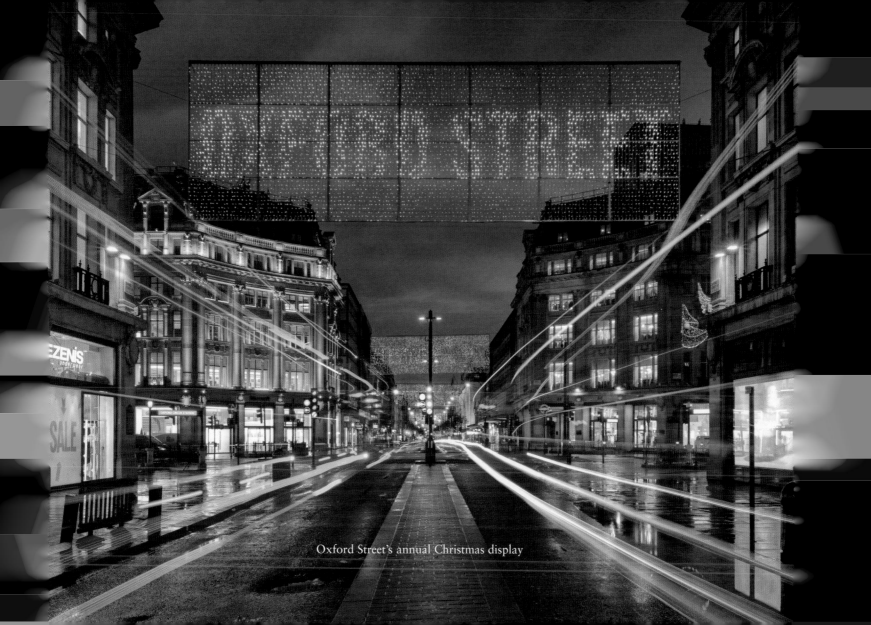

Oxford Street's annual Christmas display

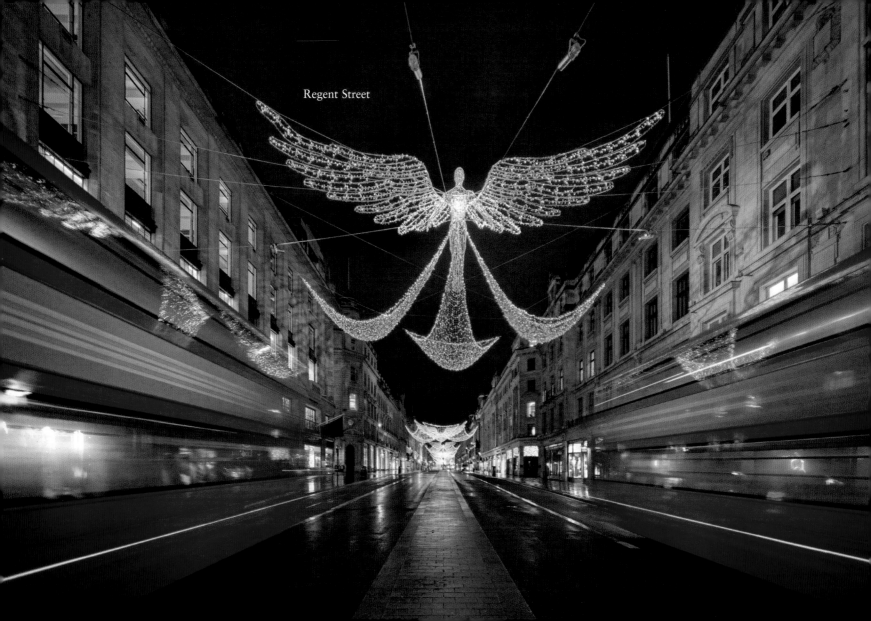

Regent Street

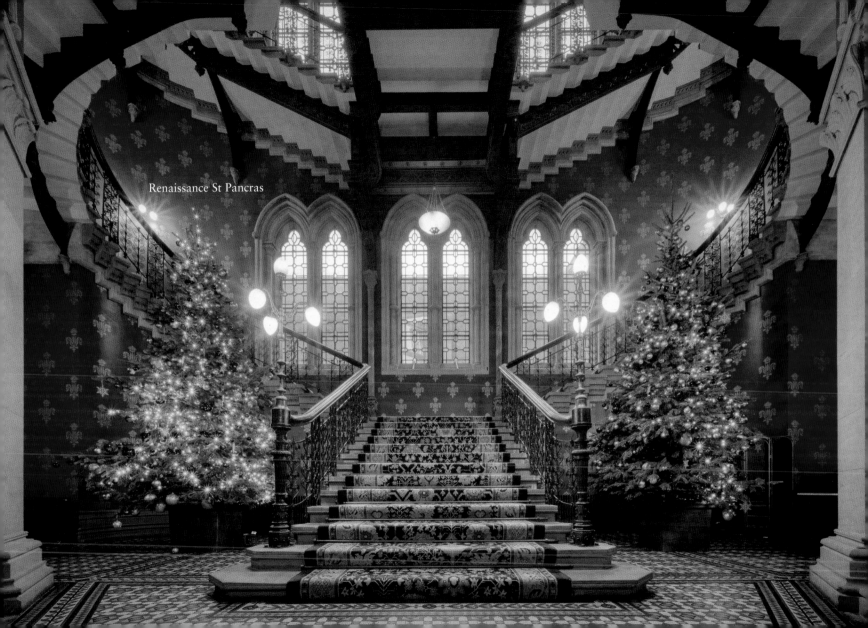

Renaissance St Pancras

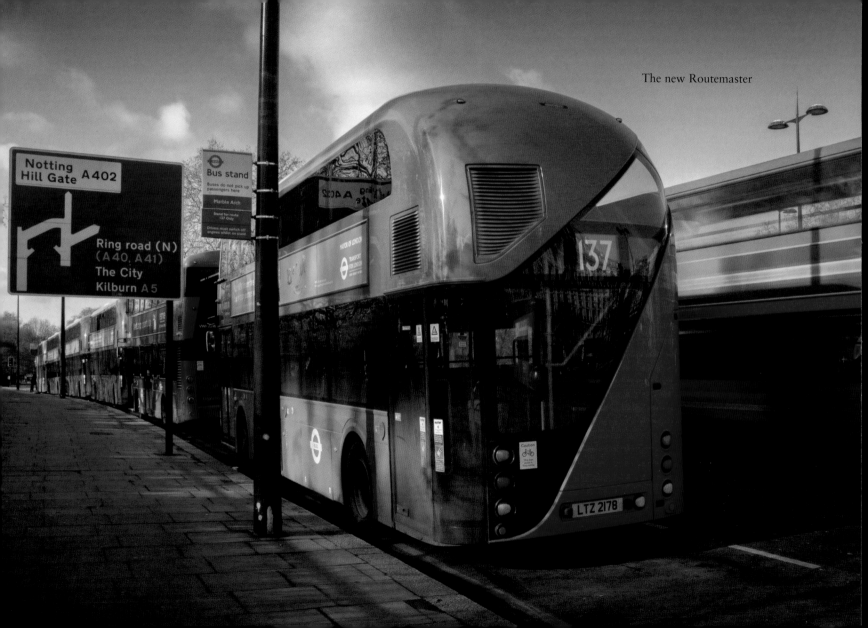

The new Routemaster

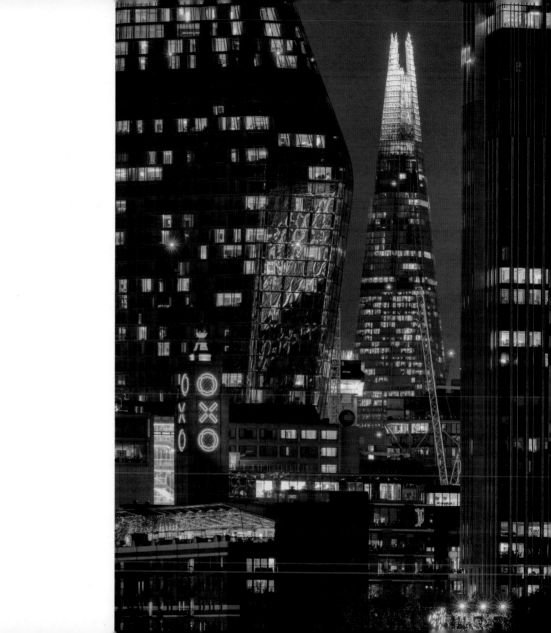

Oxo Tower, now dwarfed by its neighbours

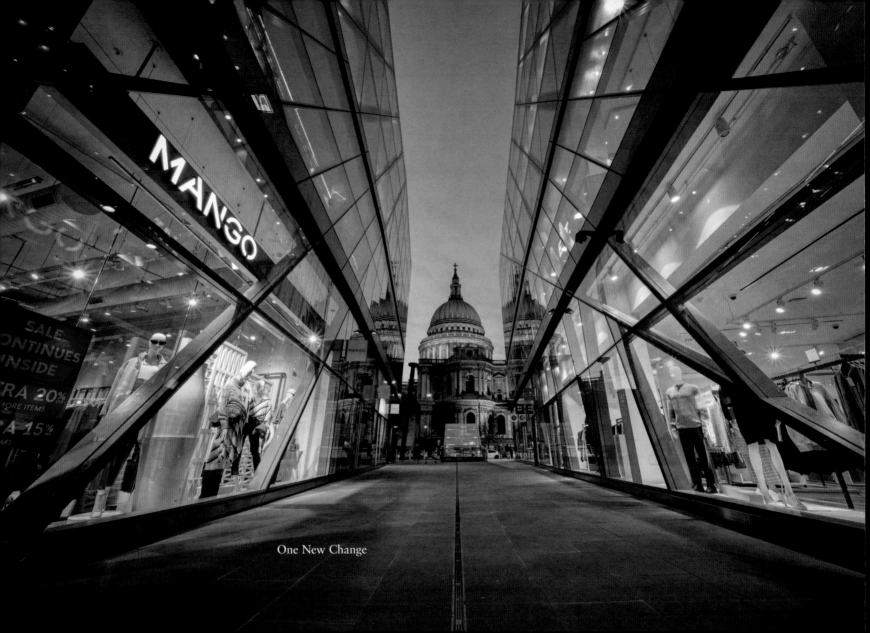

MANGO

SALE
CONTINUES
INSIDE

TRA 20%

MORE ITEMS

TA 15%

One New Change

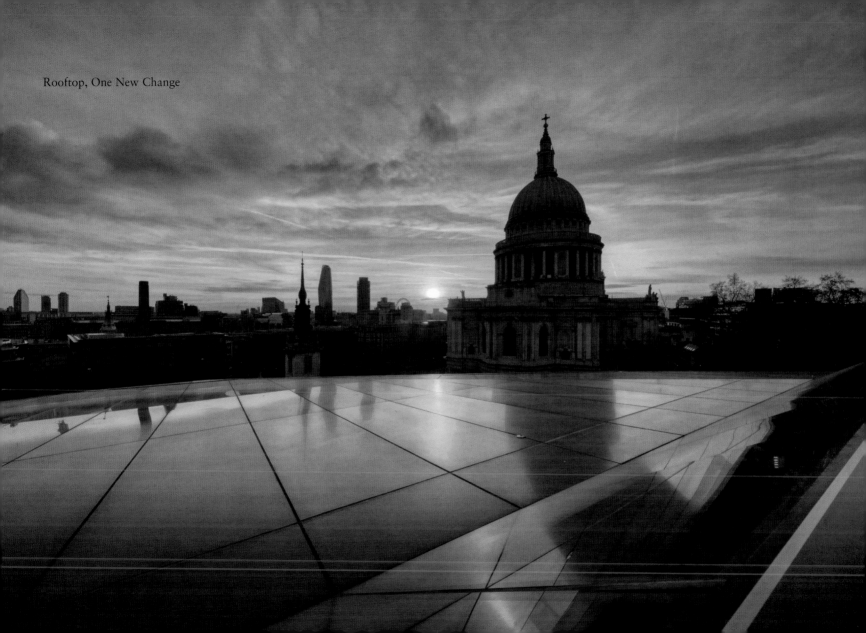

Rooftop, One New Change

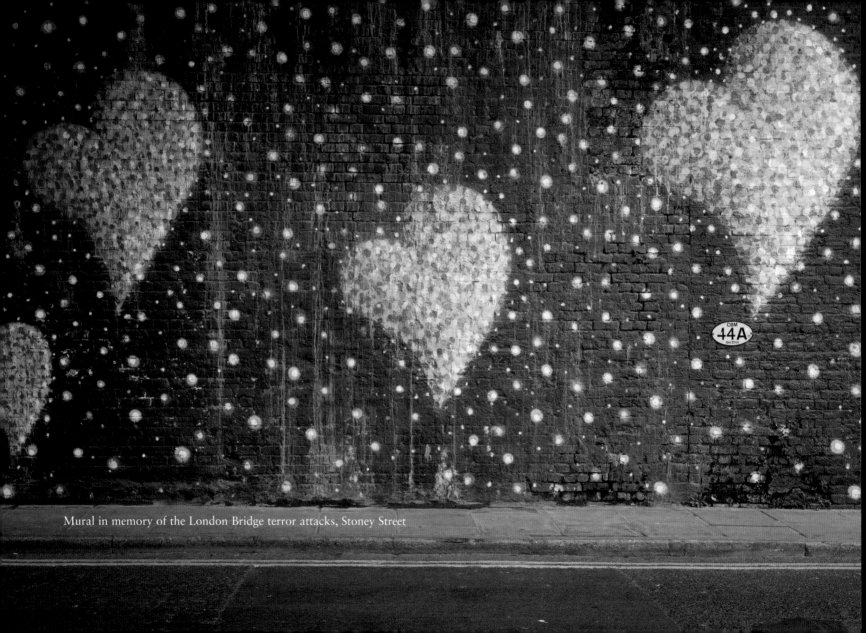

Mural in memory of the London Bridge terror attacks, Stoney Street

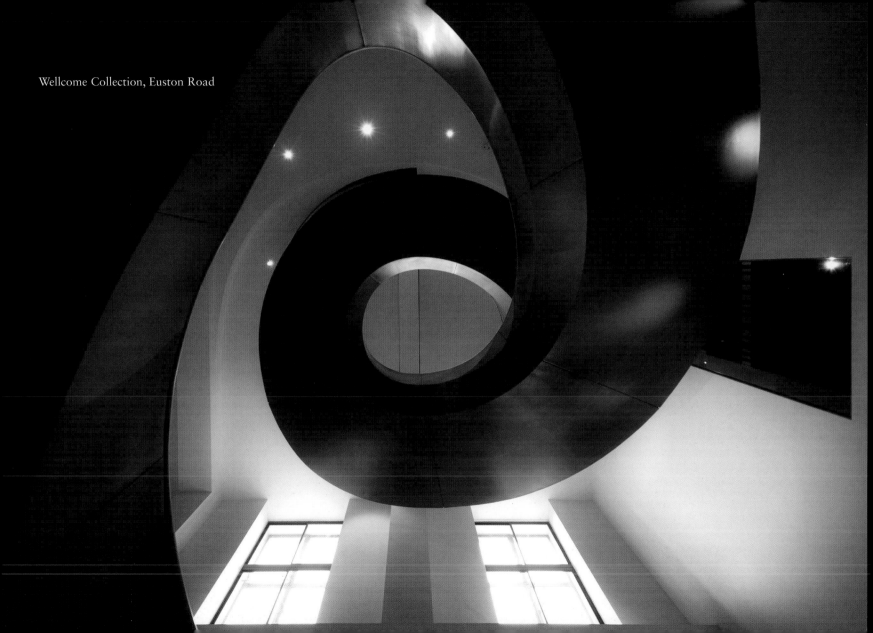

Wellcome Collection, Euston Road

NORTH

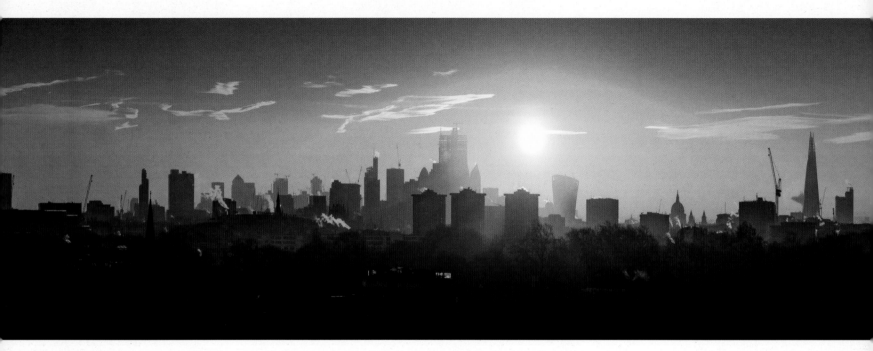

Primrose Hill

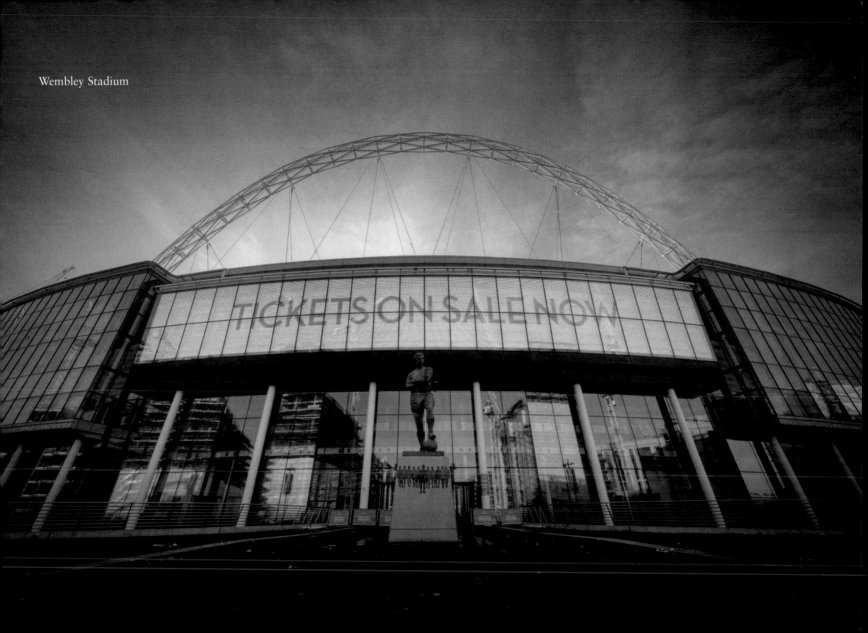

Wembley Stadium

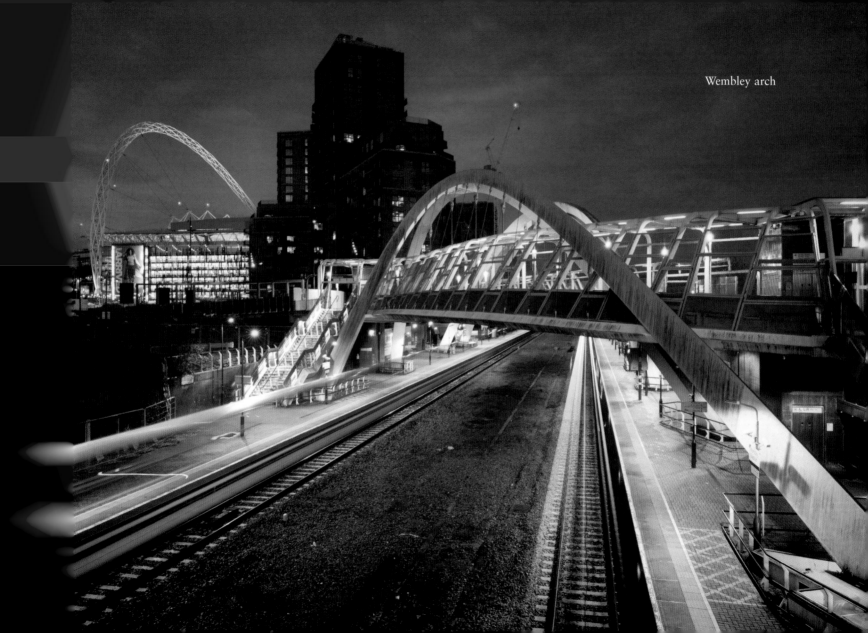

Wembley arch

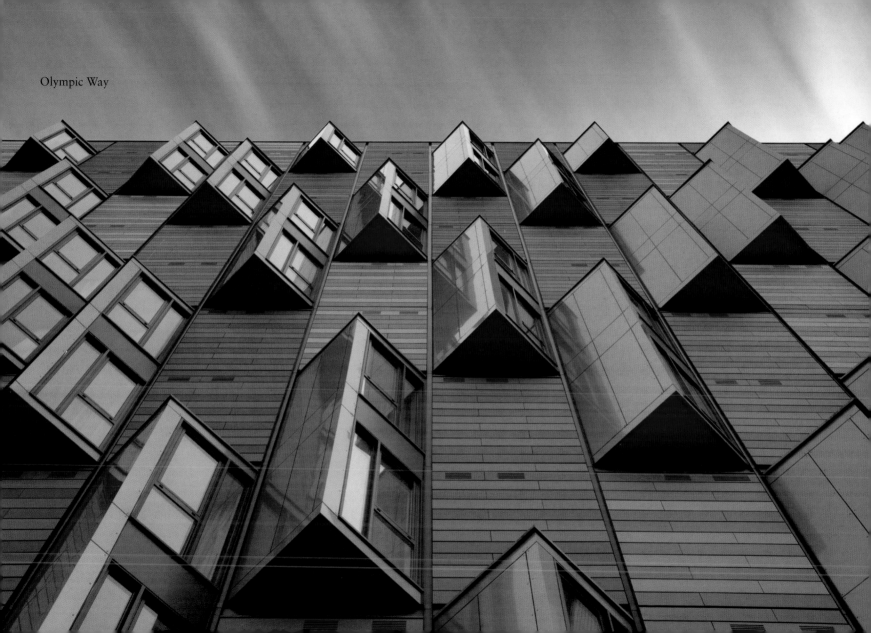

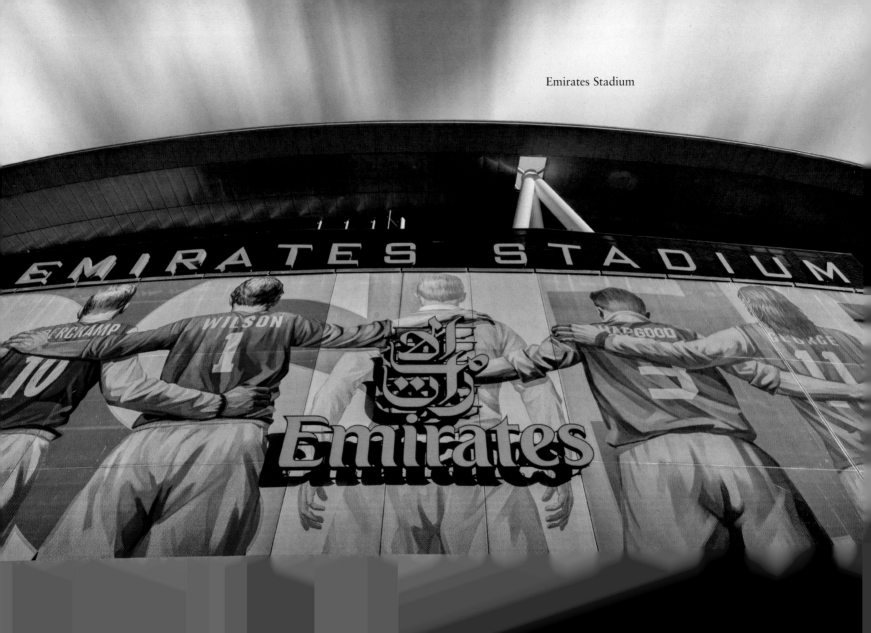

Emirates Stadium

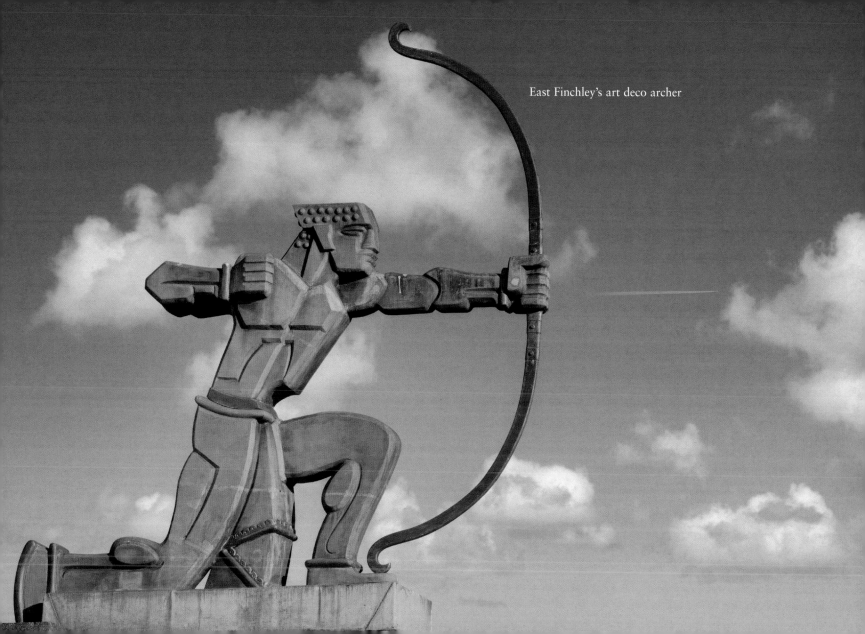

East Finchley's art deco archer

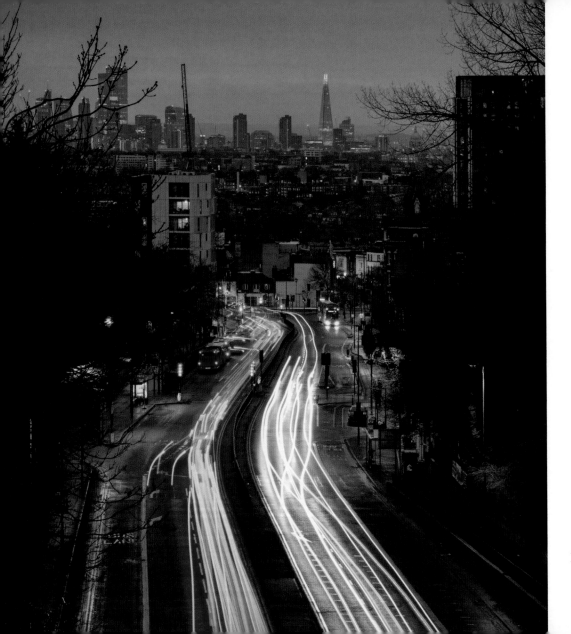

Hornsey Lane Bridge

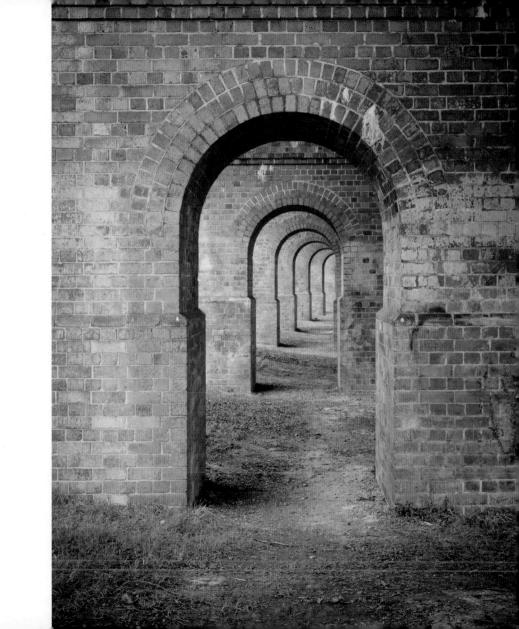

Brick viaduct, Arnos Park

WEST

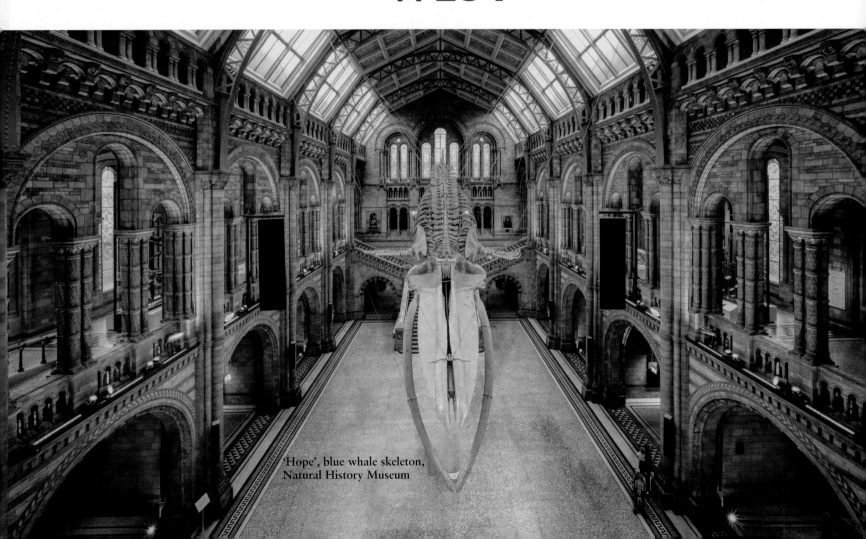

'Hope', blue whale skeleton,
Natural History Museum

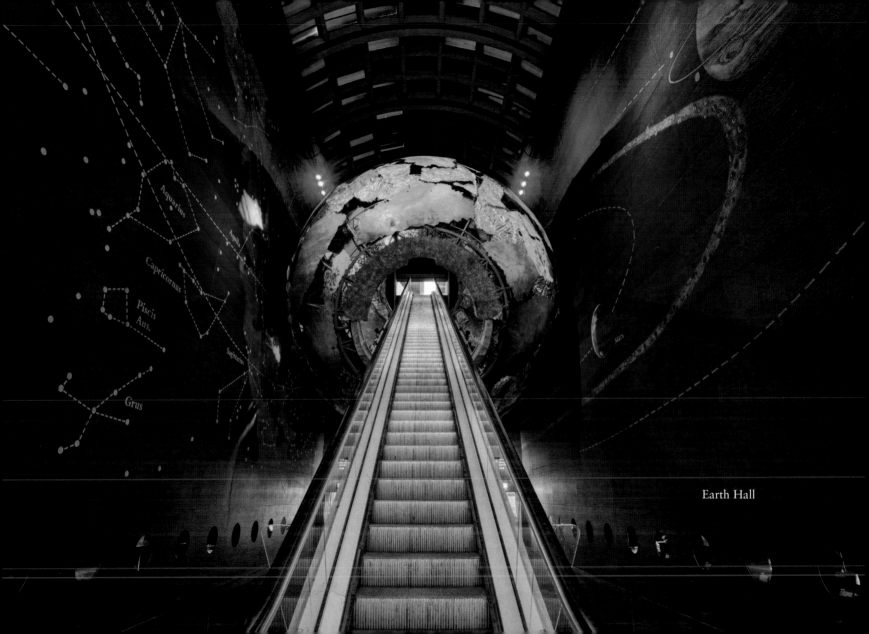

Earth Hall

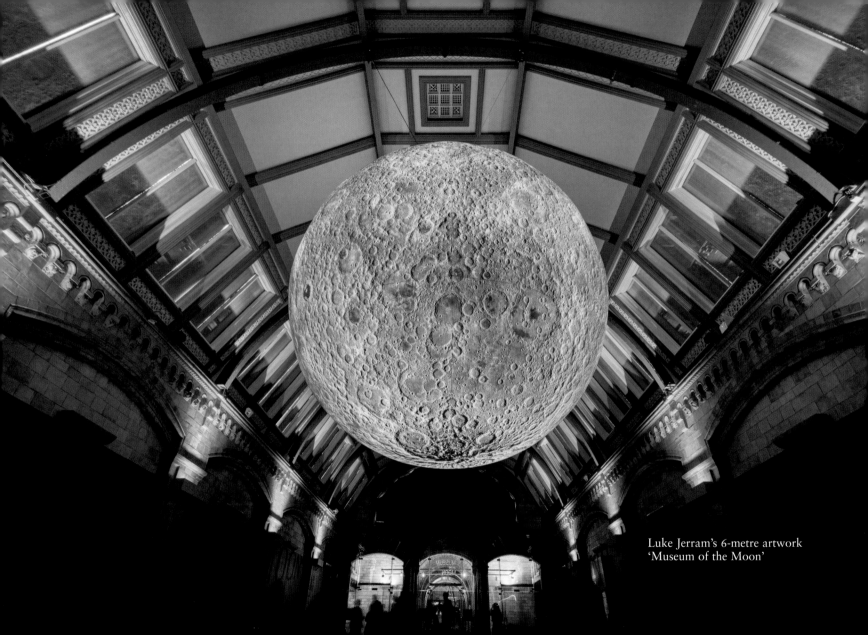

Luke Jerram's 6-metre artwork
'Museum of the Moon'

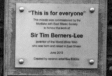

Mosaic in East Sheen

"THIS IS FOR EVERYONE"

WWW

TIM BERNERS-LEE

"This is for everyone"

This mosaic was commissioned by the
Mortlake with East Sheen Society
to honour the work of

Sir Tim Berners-Lee

inventor of the World Wide Web
who was born and raised in East Sheen

June 2015

Created by ceramic artist Sue Edkins

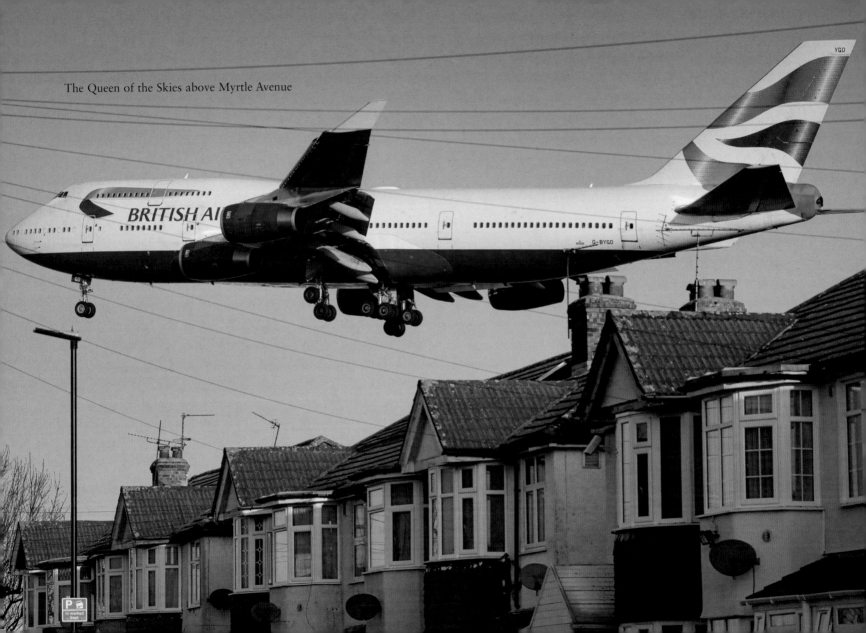

The Queen of the Skies above Myrtle Avenue

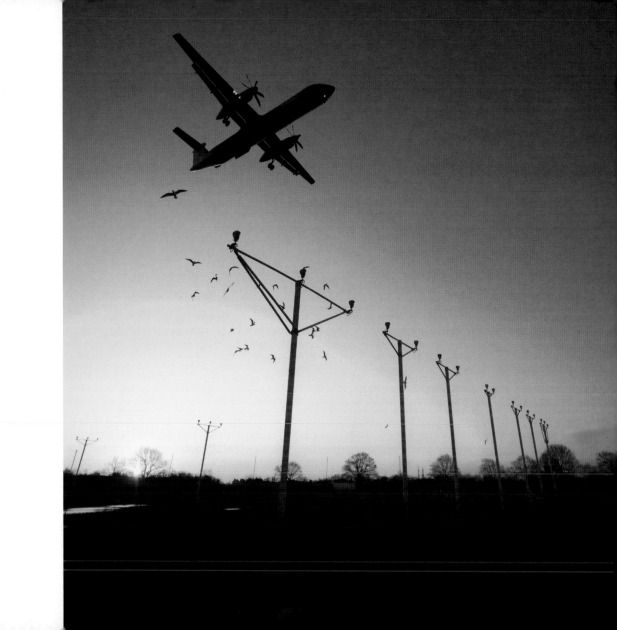

A final arrival for Flybe

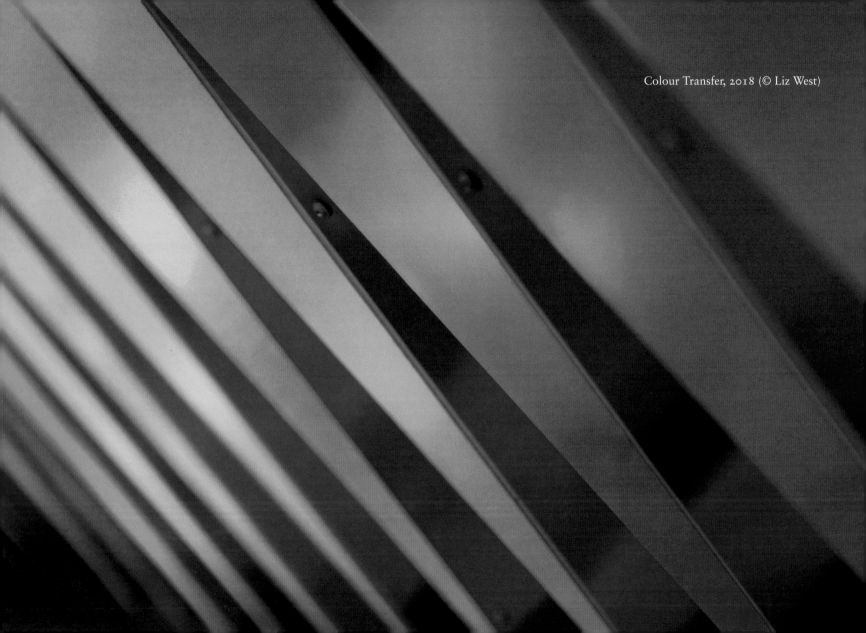

Colour Transfer, 2018 (© Liz West)

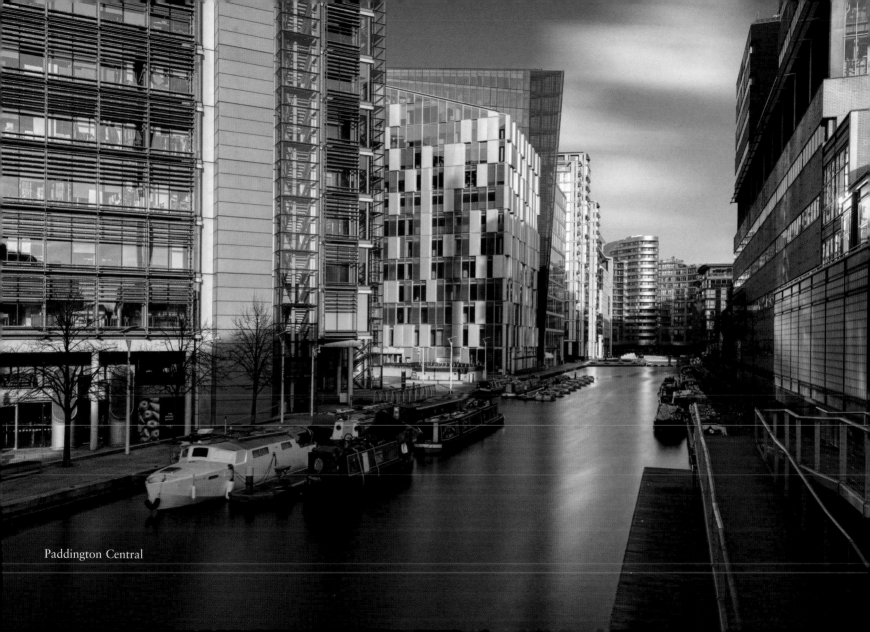

Paddington Central

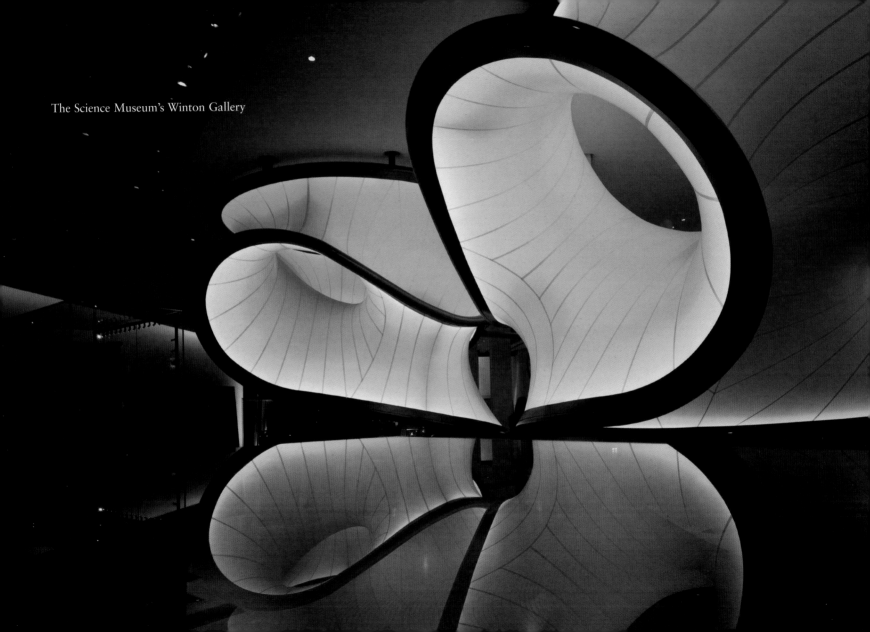

The Science Museum's Winton Gallery

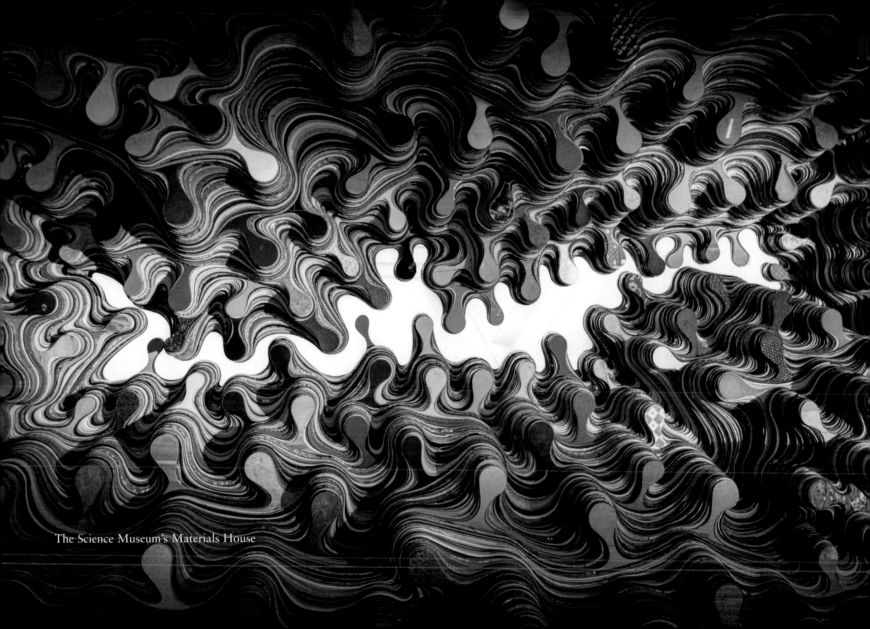

The Science Museum's Materials House

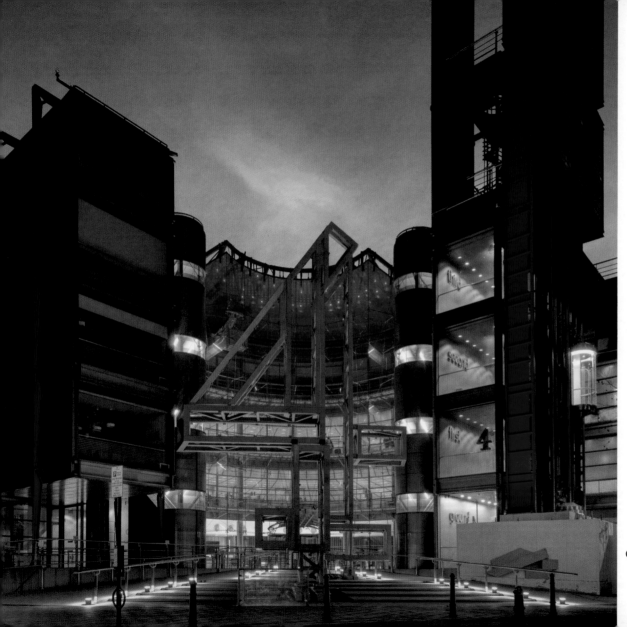

Channel 4 headquarters

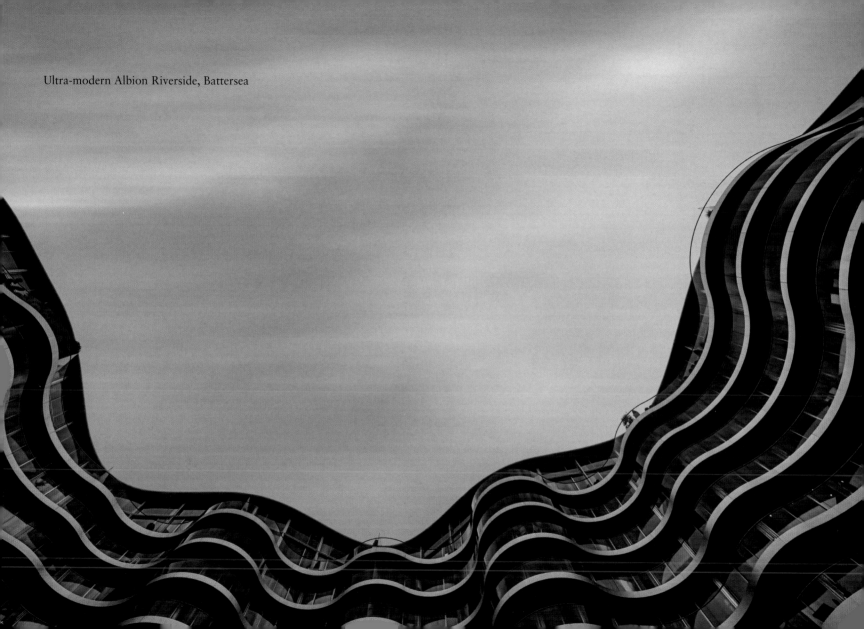

Ultra-modern Albion Riverside, Battersea

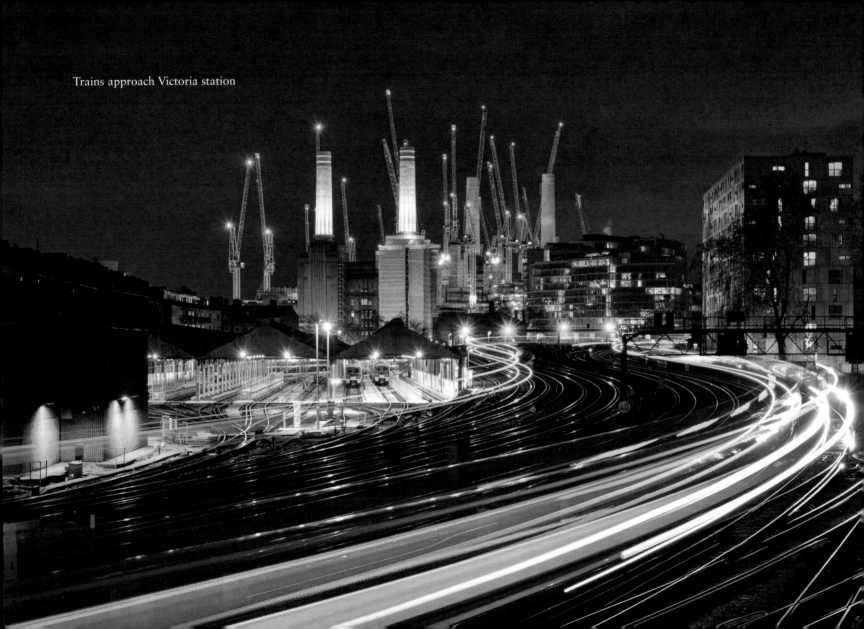
Trains approach Victoria station

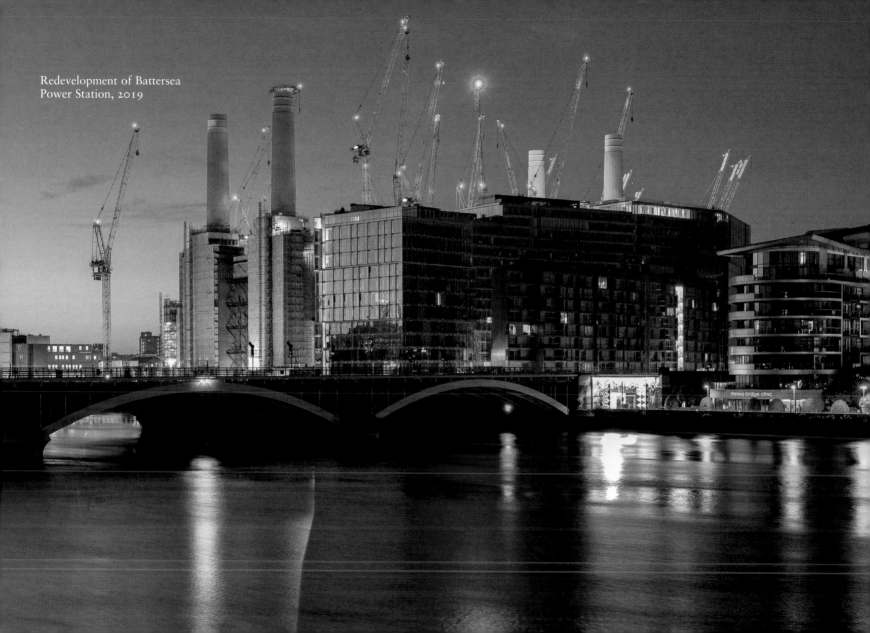

Redevelopment of Battersea
Power Station, 2019

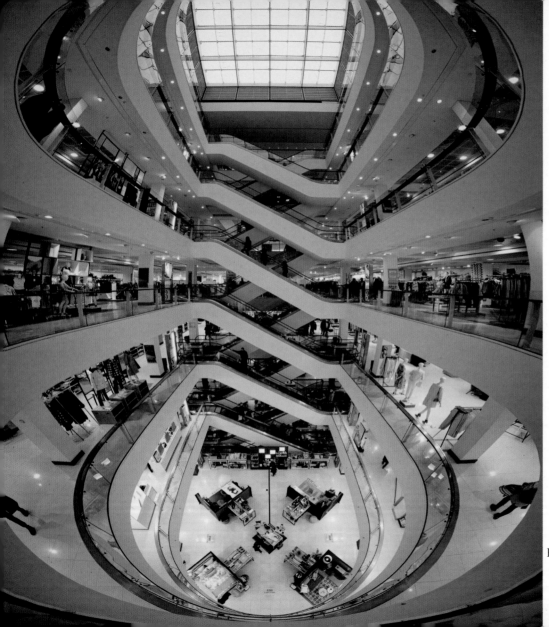

Refurbishment of the flagship Peter Jones store

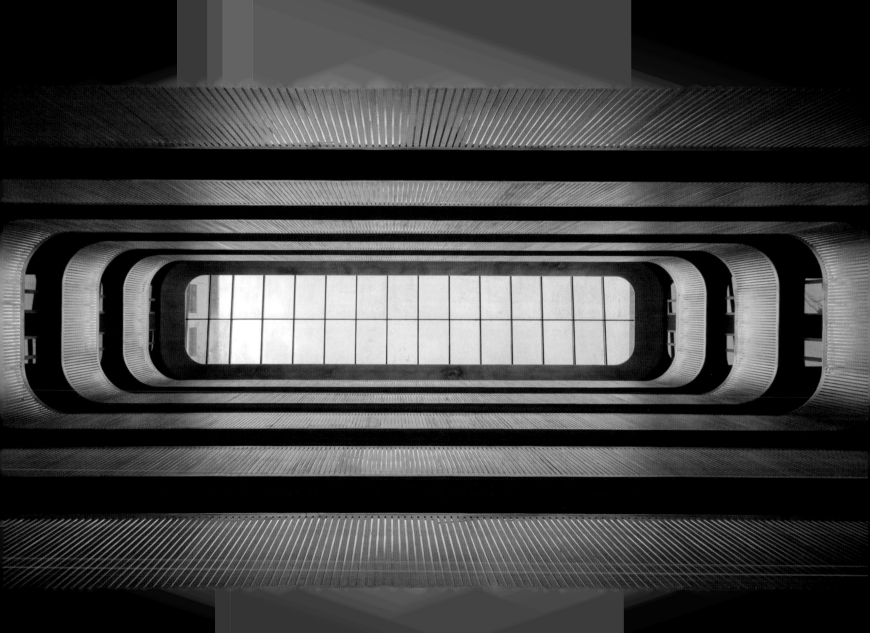

SOUTH

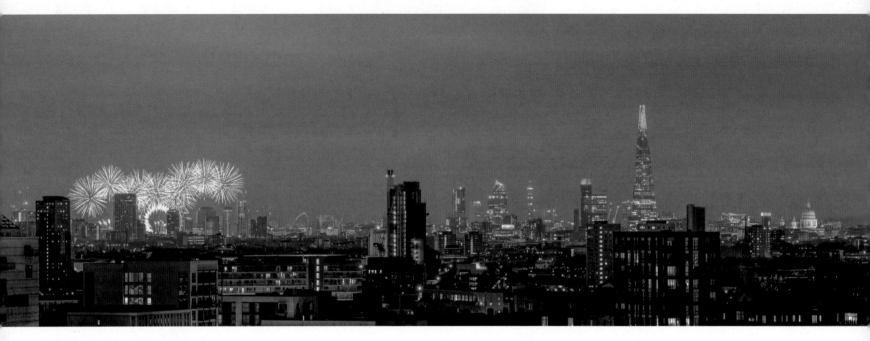

New Year from Greenwich

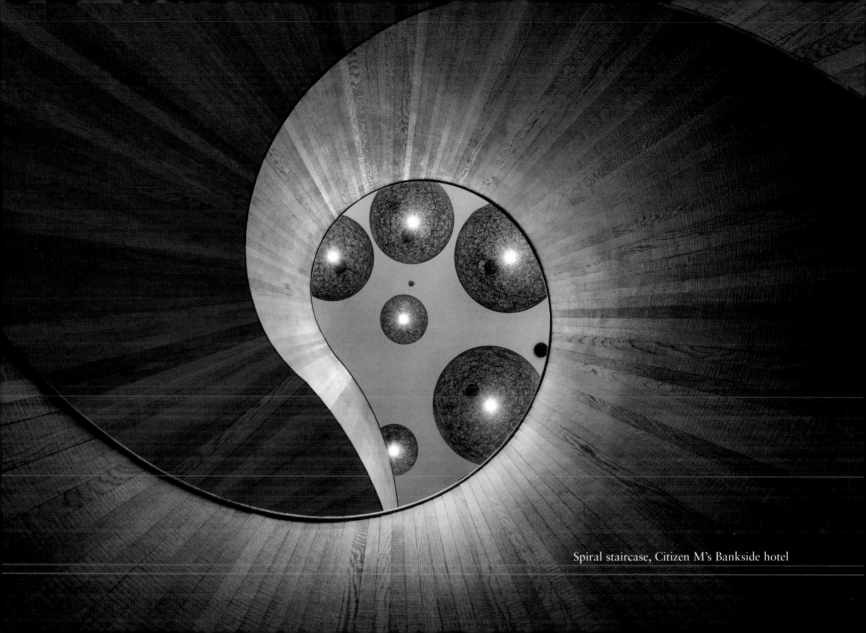

Spiral staircase, Citizen M's Bankside hotel

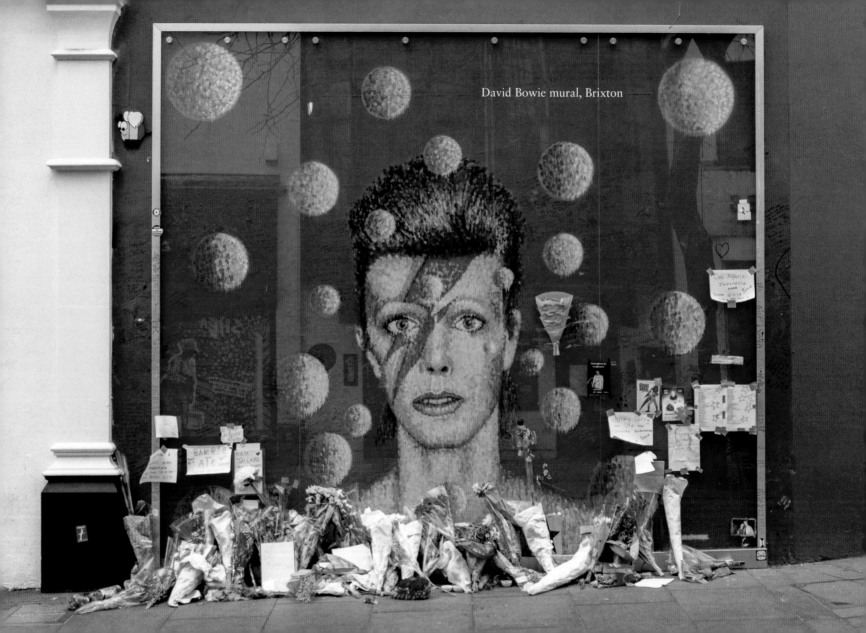

David Bowie mural, Brixton

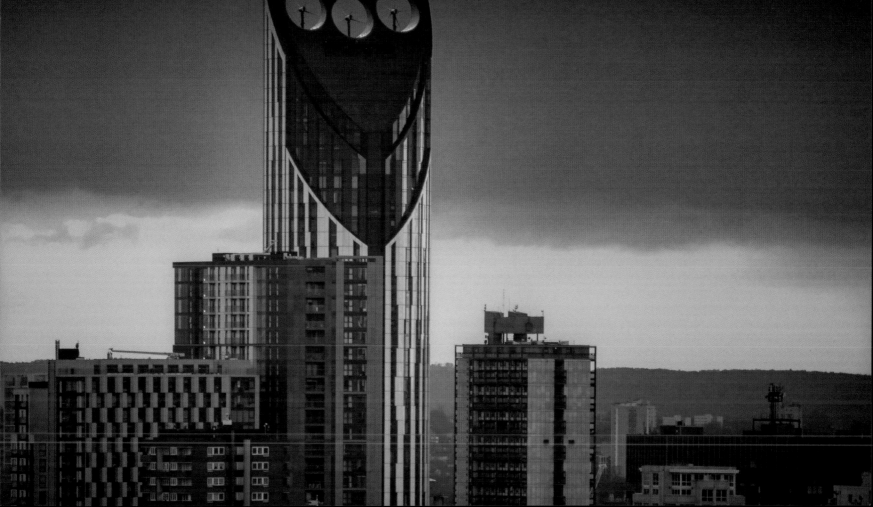

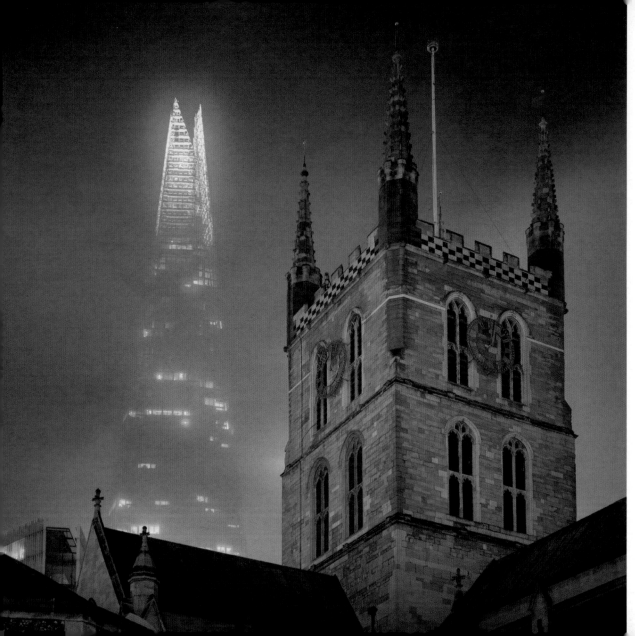

Renzo Piano's Shard

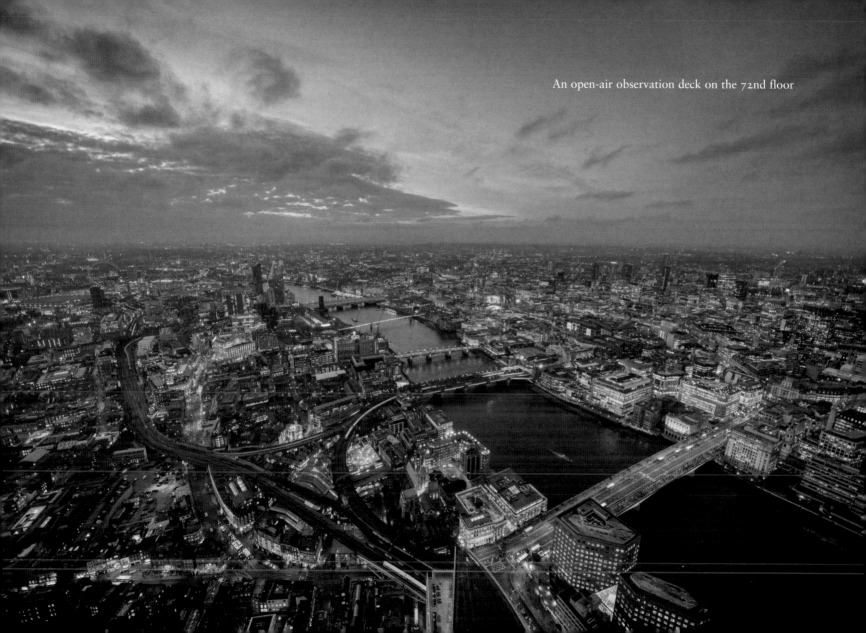

An open-air observation deck on the 72nd floor

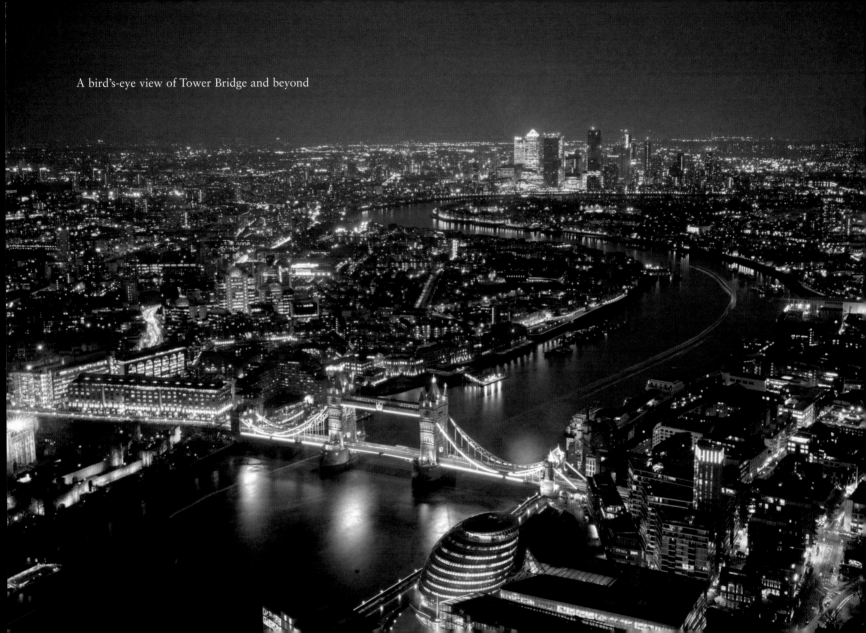

A bird's-eye view of Tower Bridge and beyond

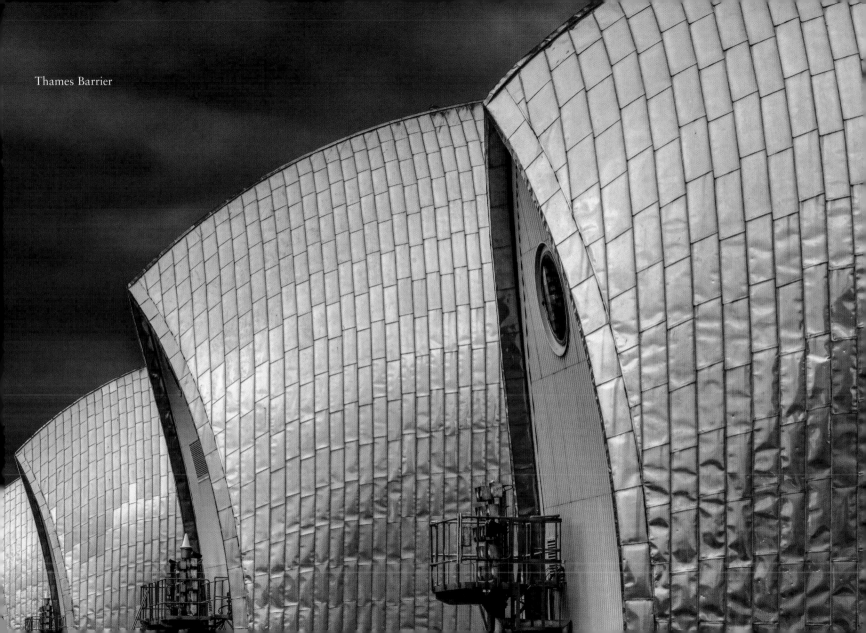

Thames Barrier

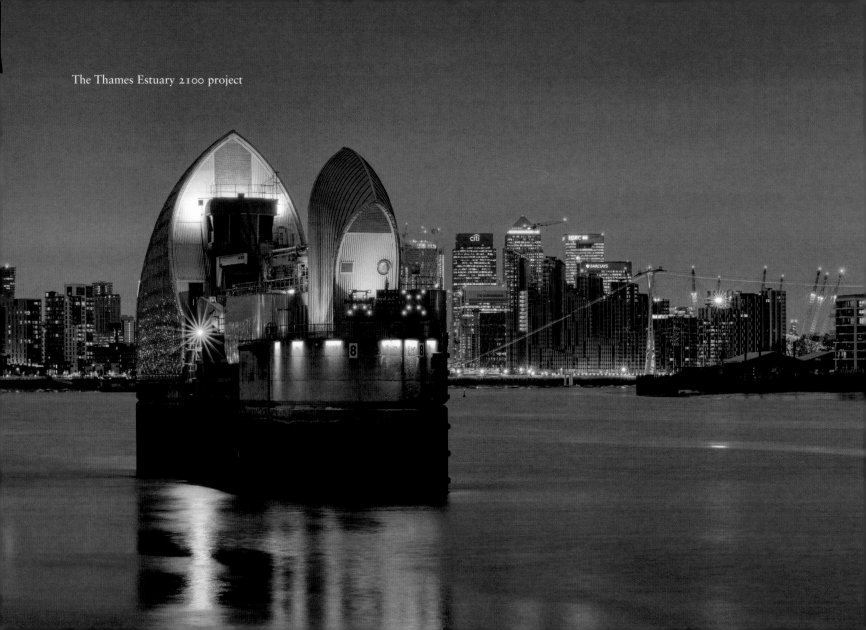

The Thames Estuary 2100 project

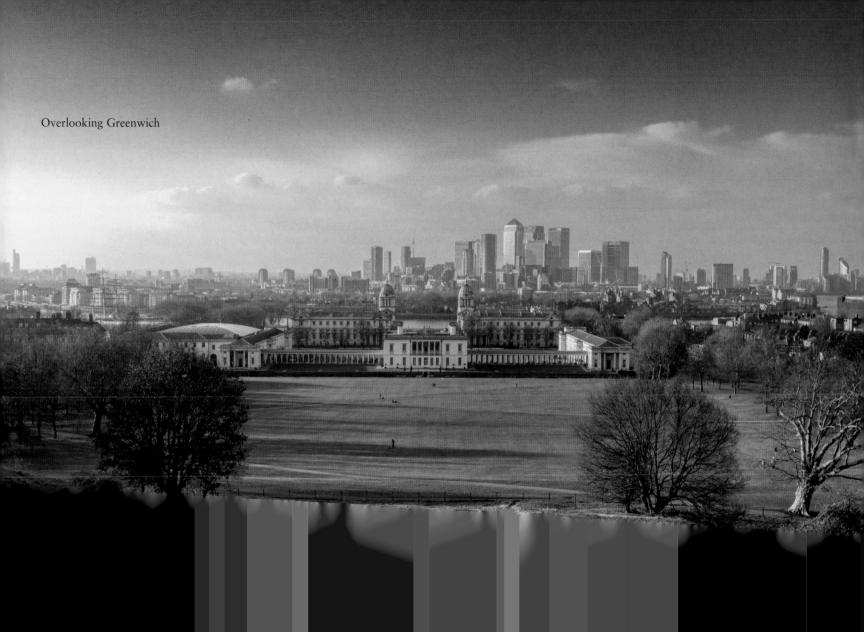

Overlooking Greenwich

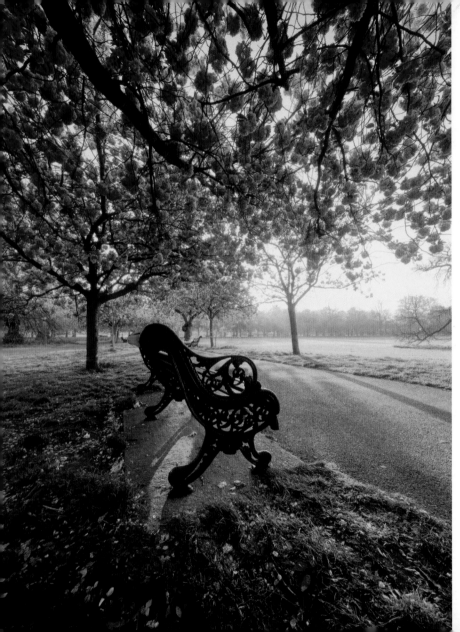

Cherry blossom displays, Greenwich Park

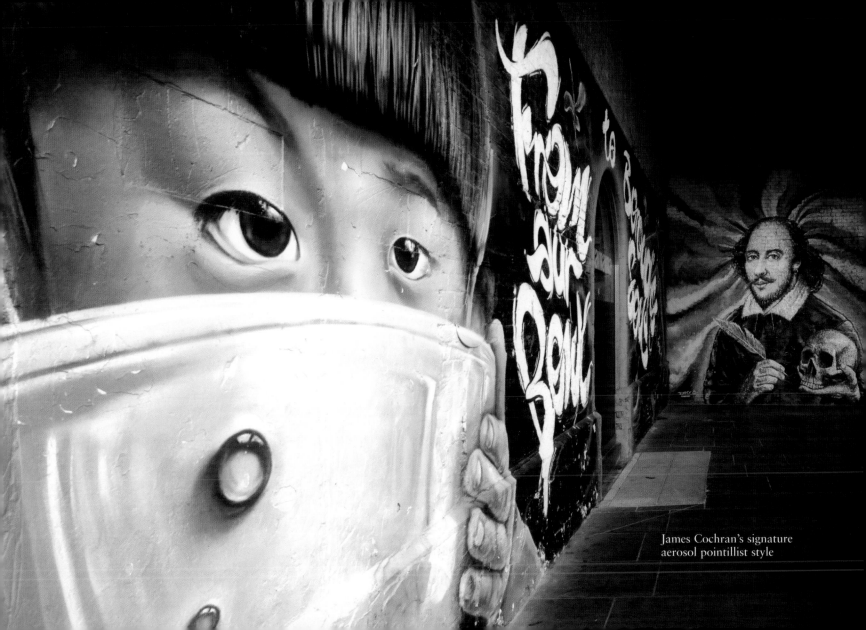

James Cochran's signature
aerosol pointillist style

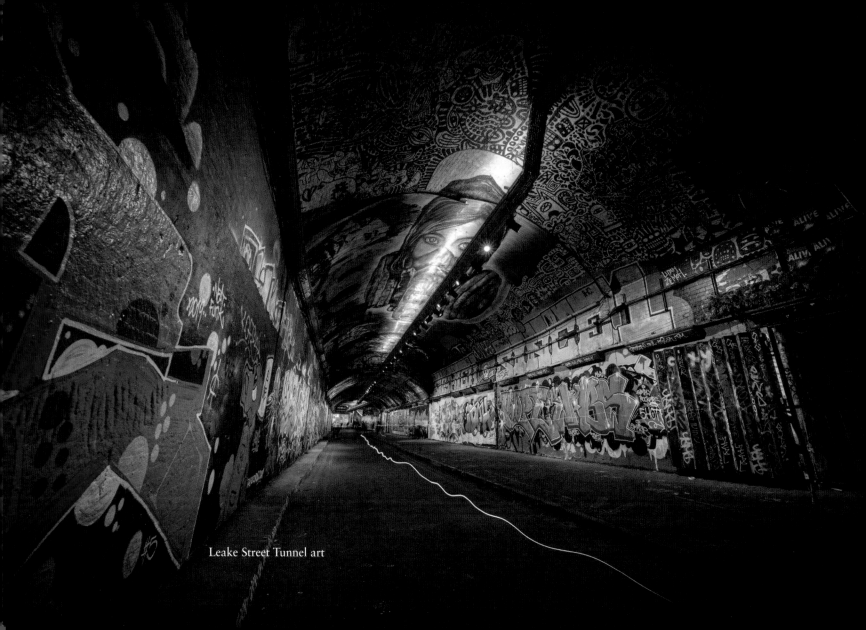

Leake Street Tunnel art

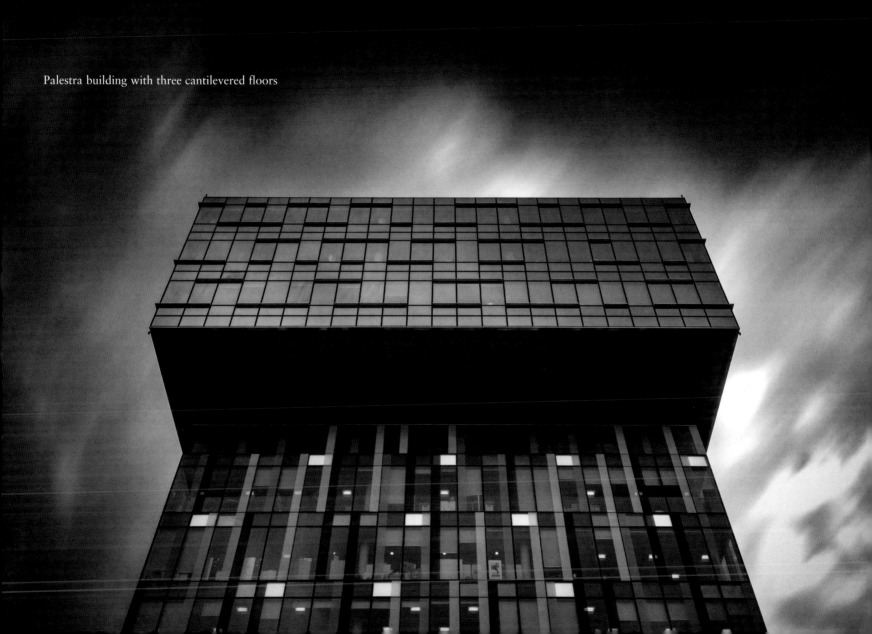

Palestra building with three cantilevered floors

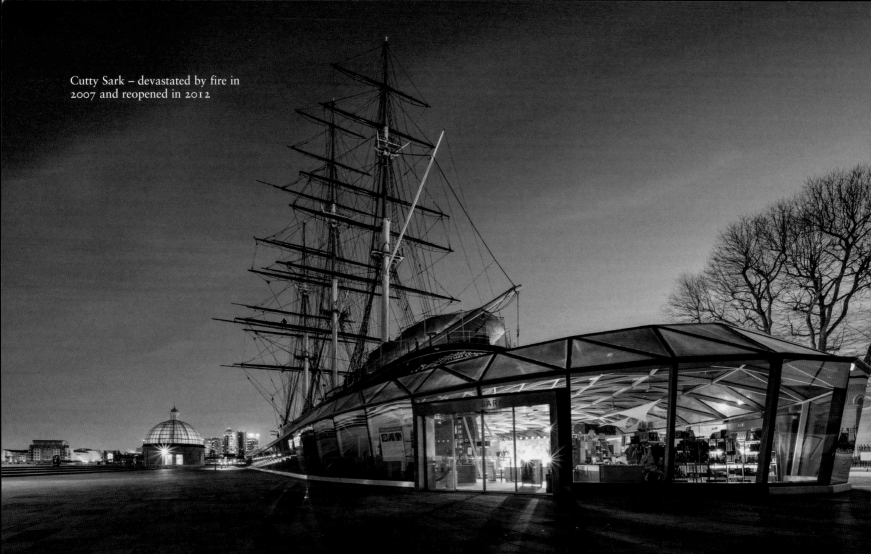

Cutty Sark – devastated by fire in
2007 and reopened in 2012

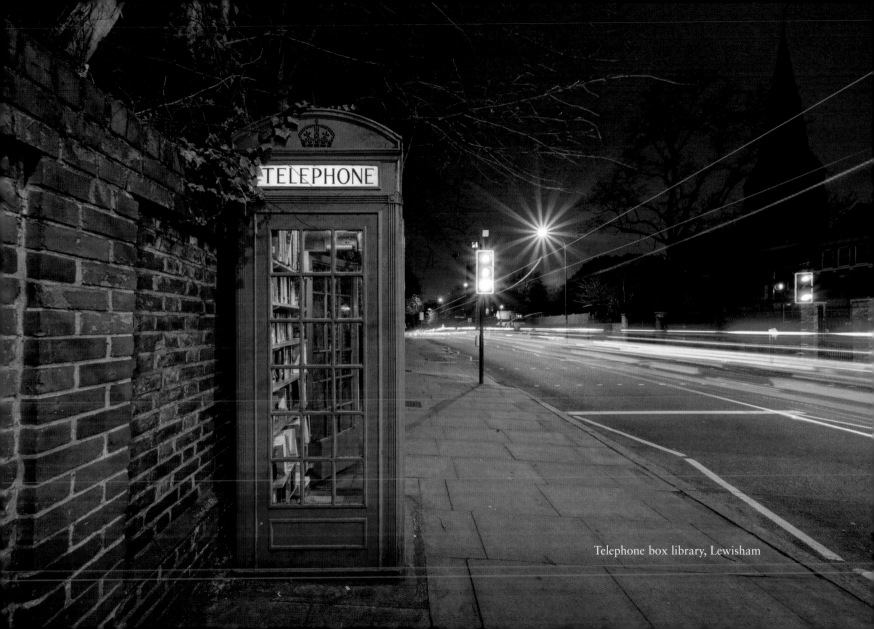

Telephone box library, Lewisham

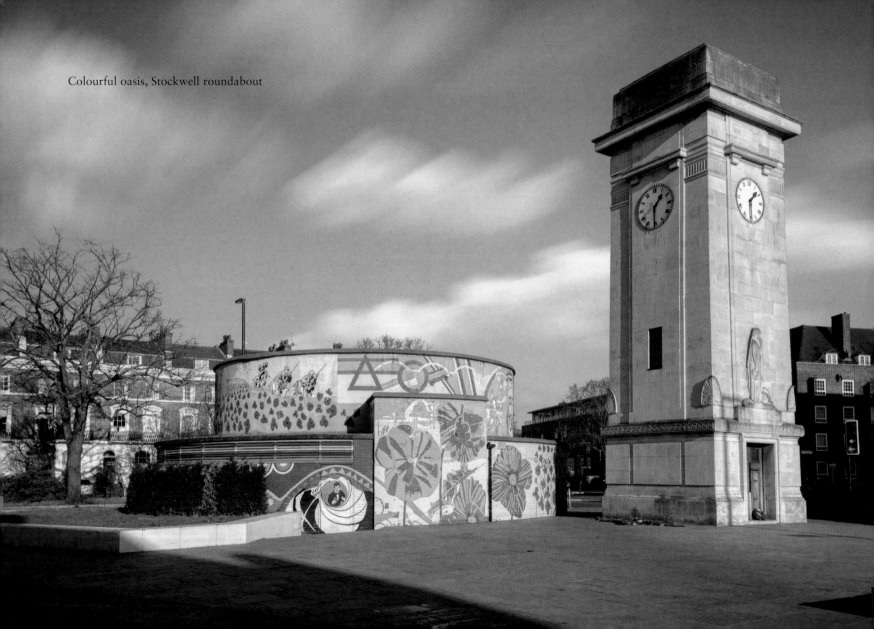

Colourful oasis, Stockwell roundabout

Simon Whybray's 'hi boo i love you' (2016). (© Bold Tendencies)

EAST

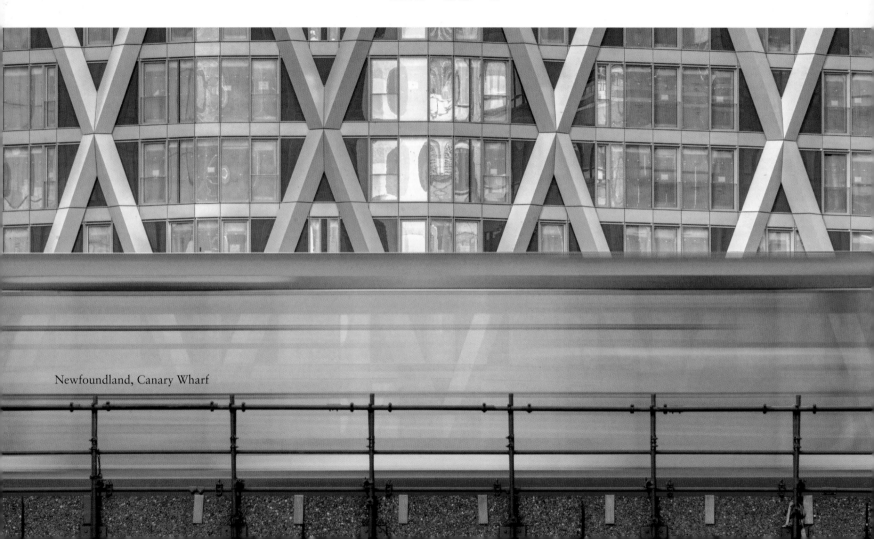

Newfoundland, Canary Wharf

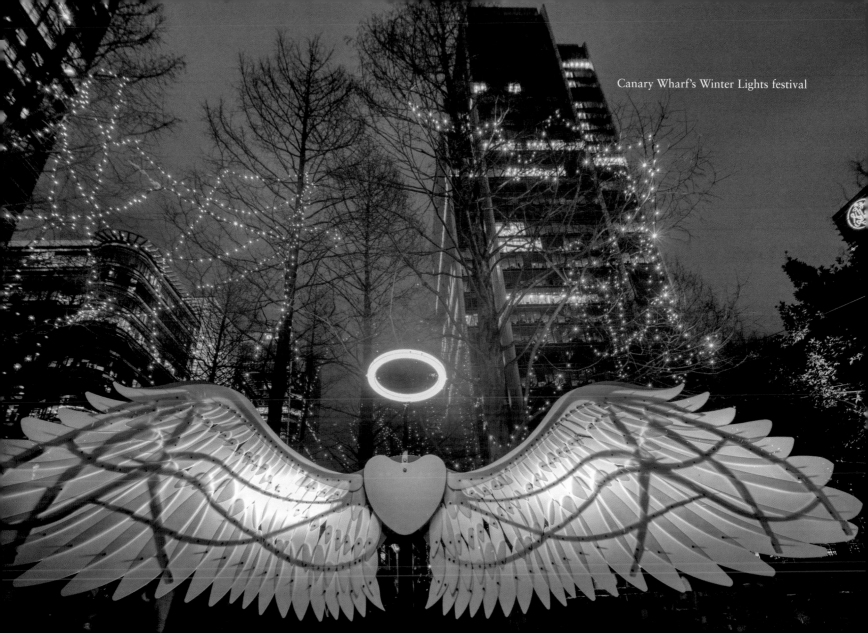

Canary Wharf's Winter Lights festival

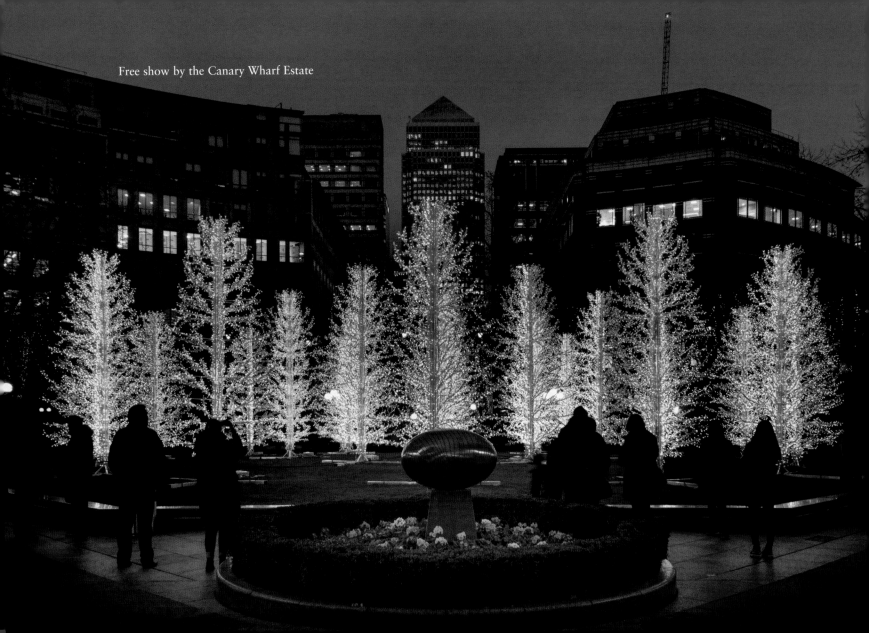

Free show by the Canary Wharf Estate

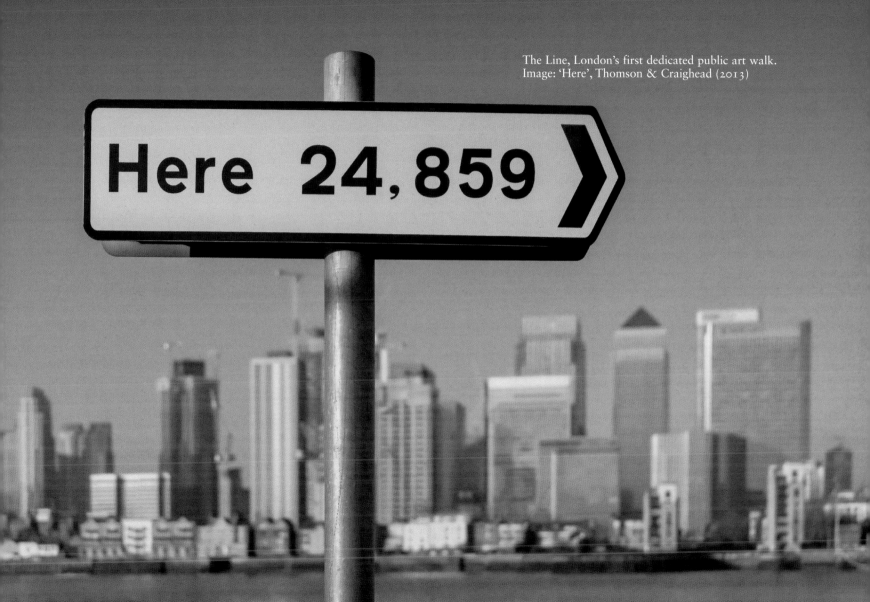

The Line, London's first dedicated public art walk.
Image: 'Here', Thomson & Craighead (2013)

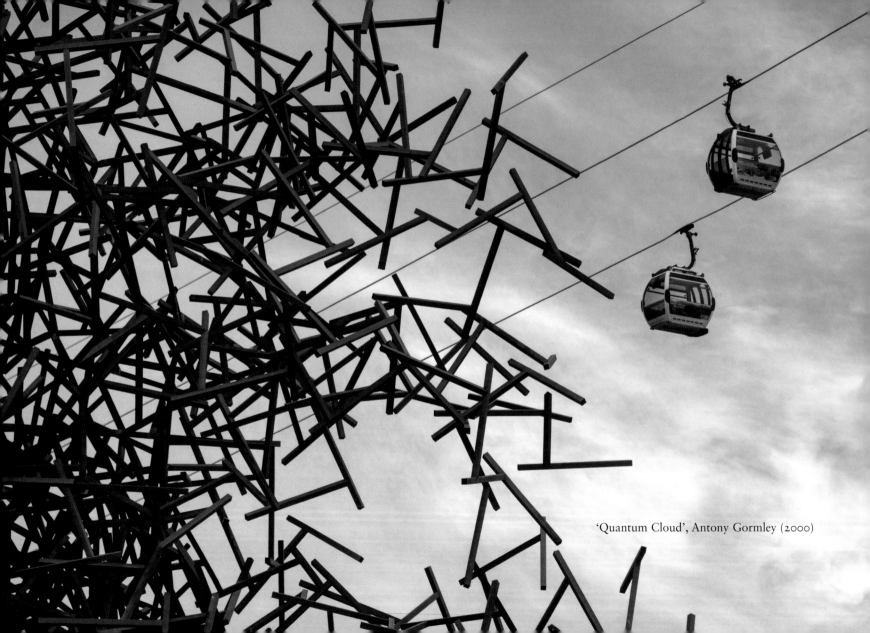

'Quantum Cloud', Antony Gormley (2000)

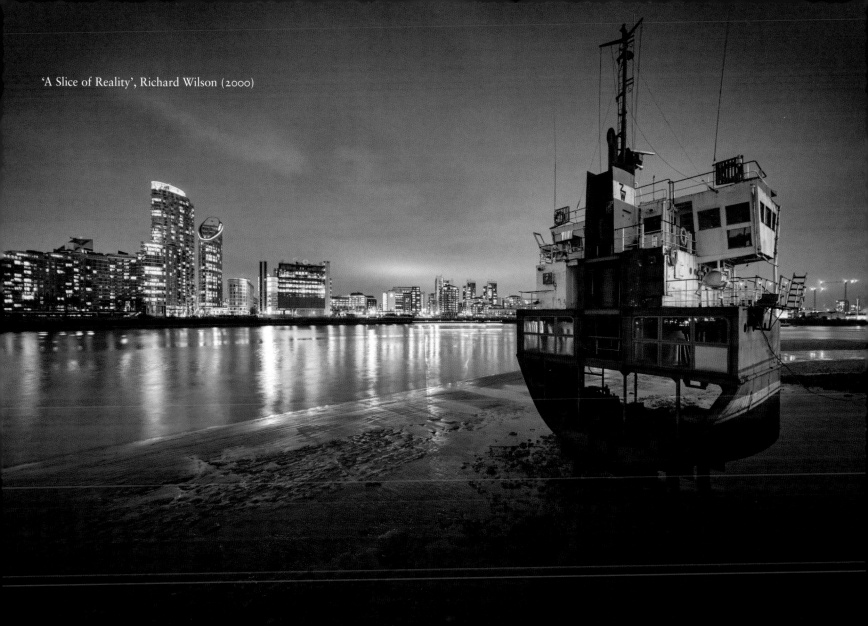

'A Slice of Reality', Richard Wilson (2000)

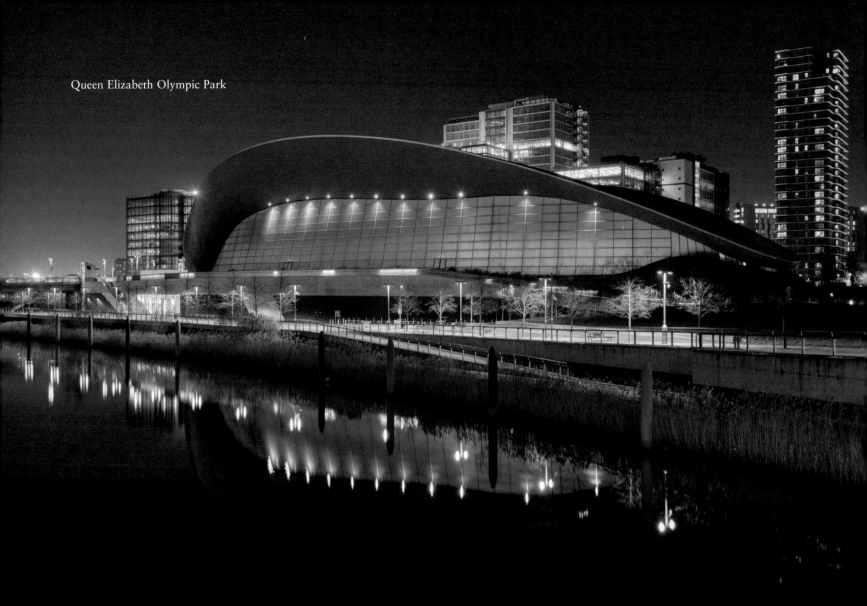

Queen Elizabeth Olympic Park

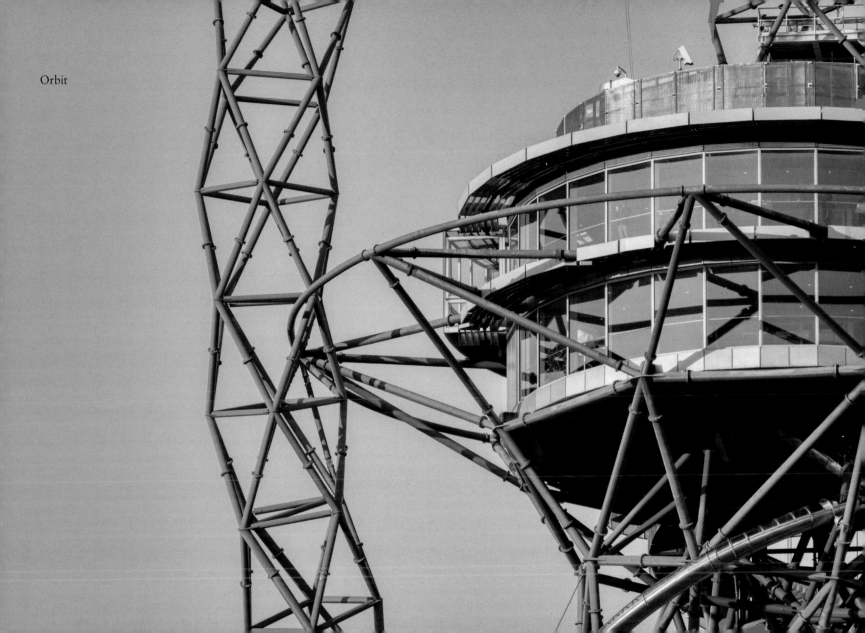

Orbit

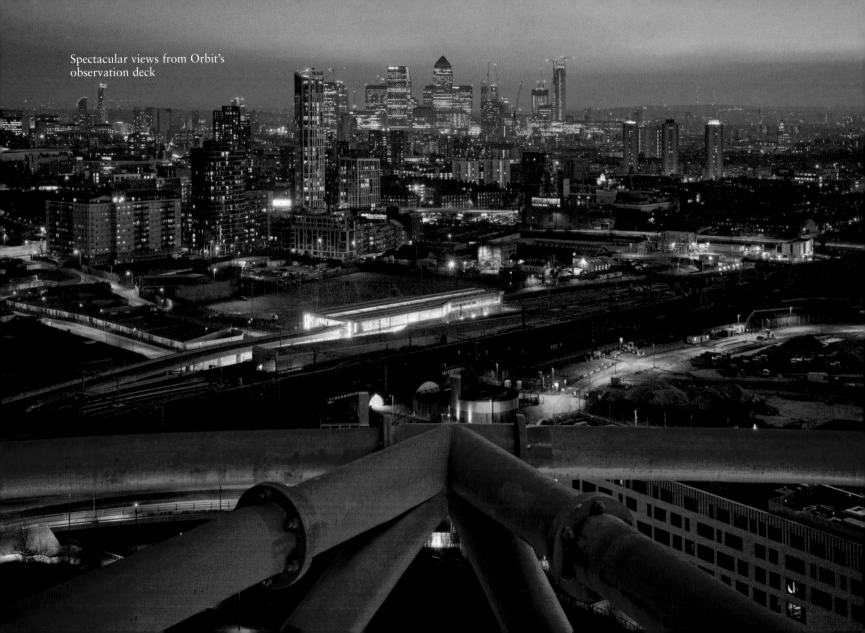

Spectacular views from Orbit's observation deck

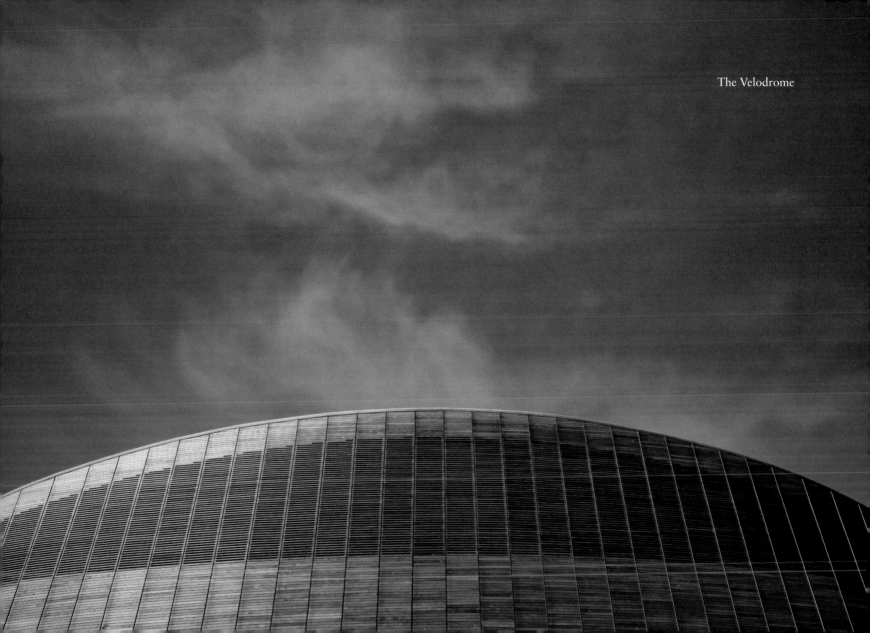

The Velodrome

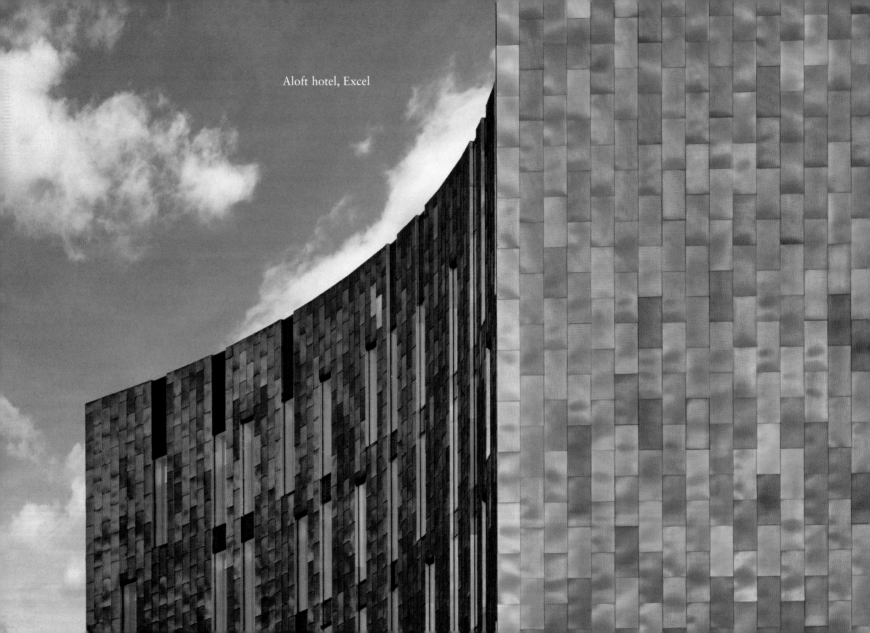

Aloft hotel, Excel

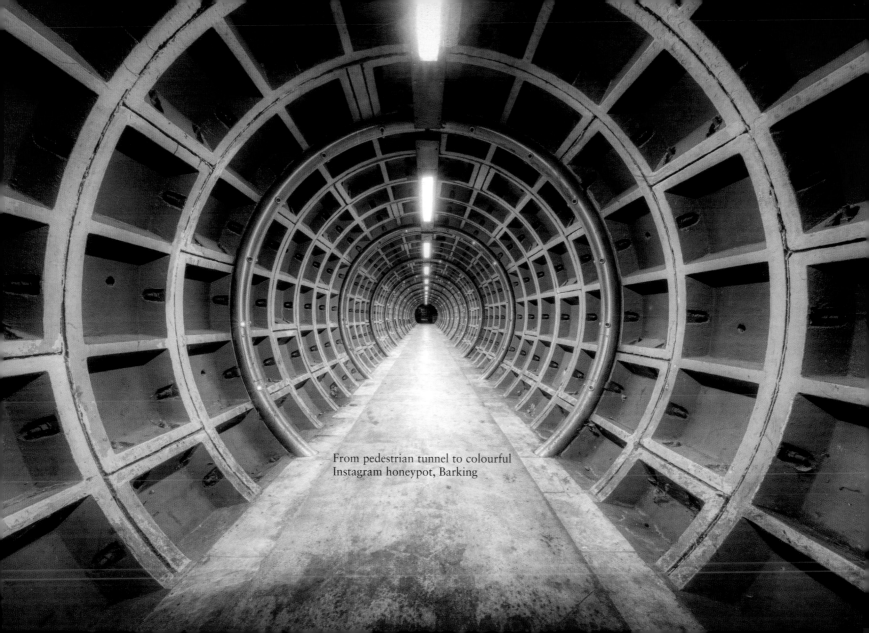

From pedestrian tunnel to colourful
Instagram honeypot, Barking

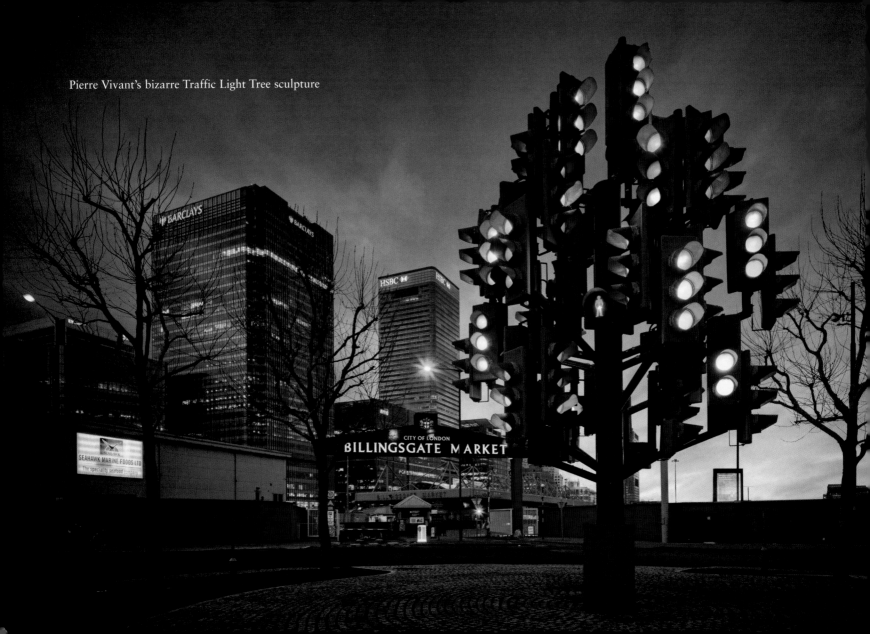

Pierre Vivant's bizarre Traffic Light Tree sculpture

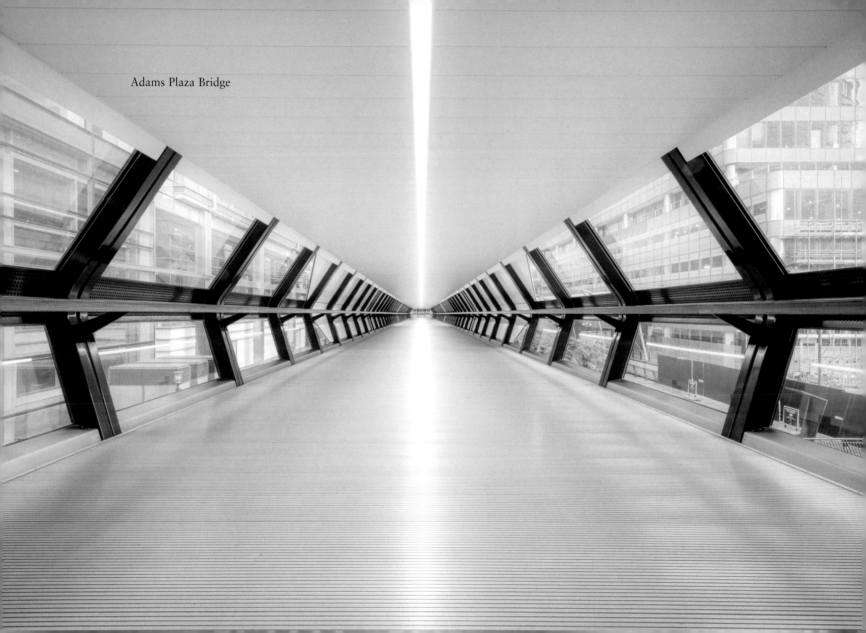

Adams Plaza Bridge

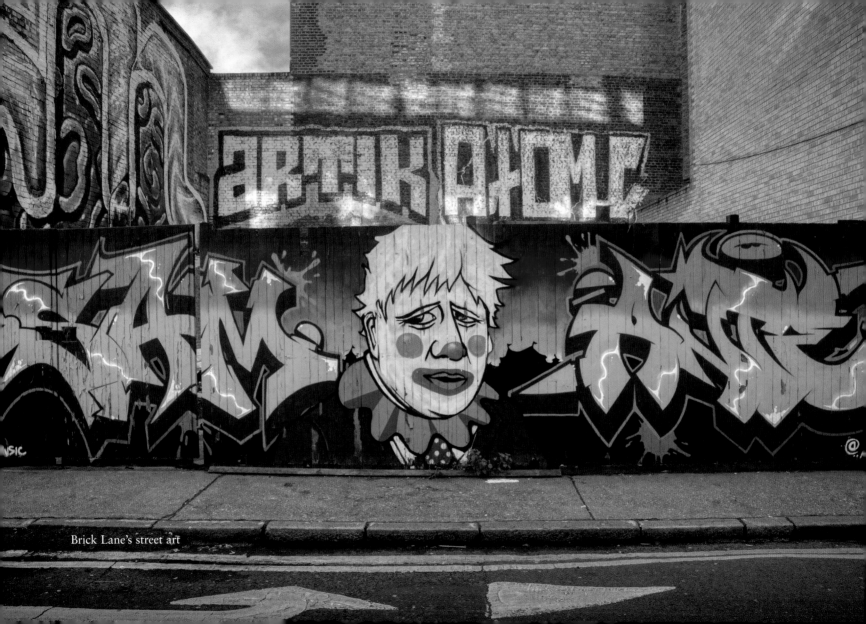

Brick Lane's street art

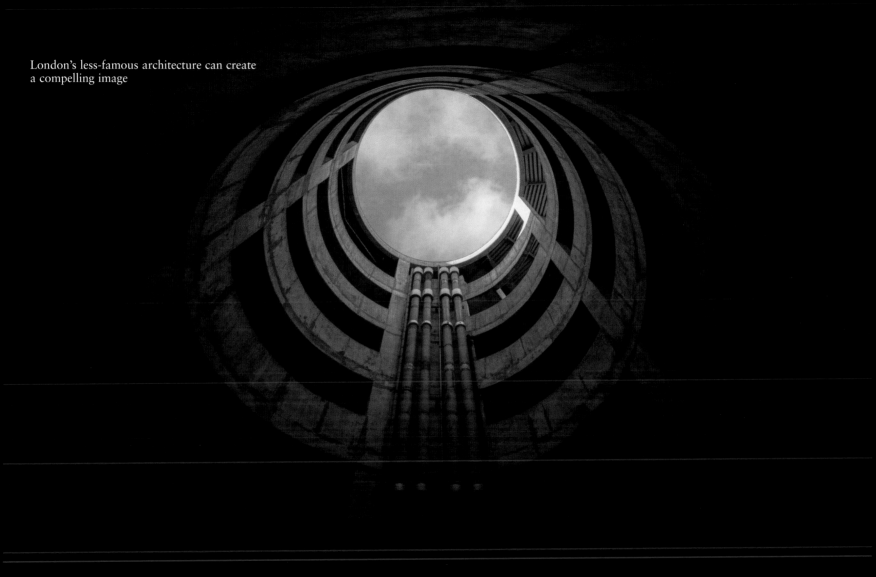

London's less-famous architecture can create
a compelling image

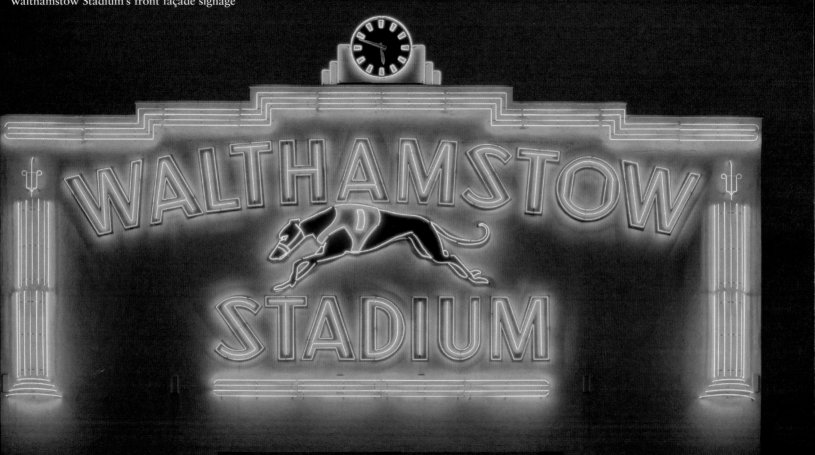

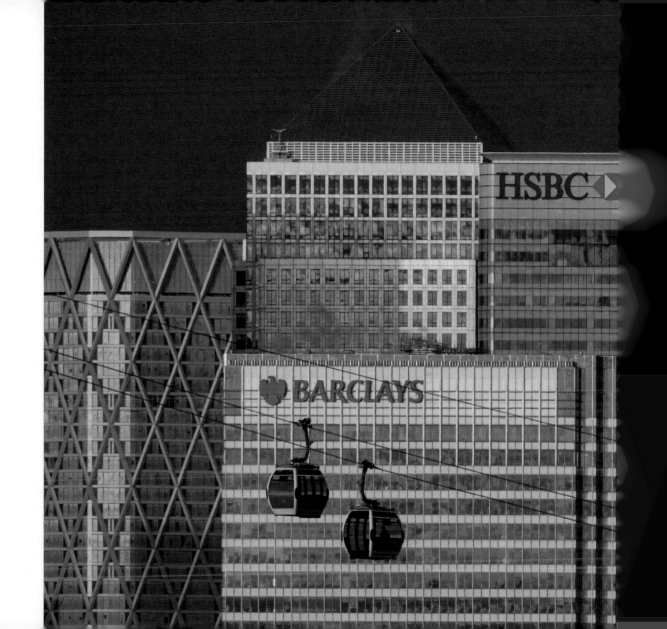

Canary Wharf's towers

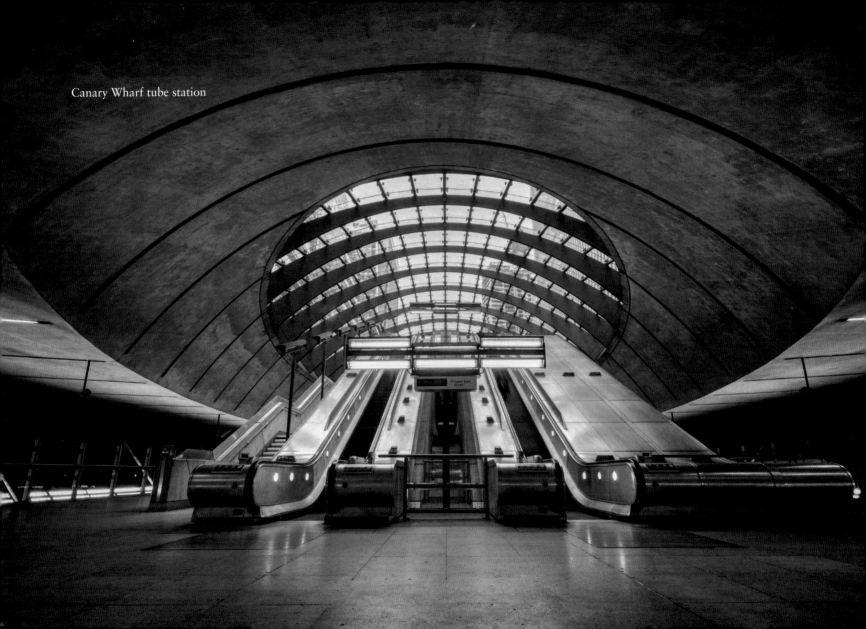

Canary Wharf tube station

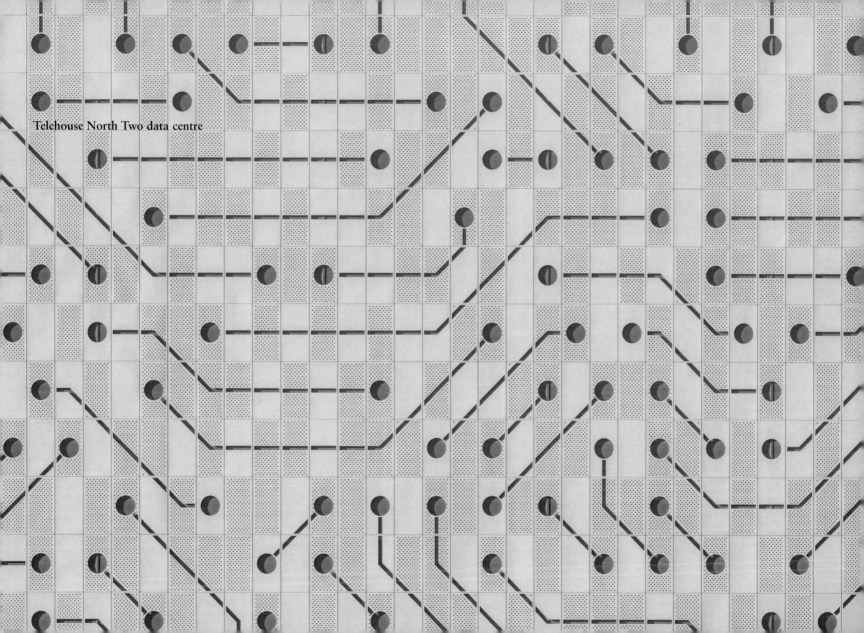

Telehouse North Two data centre

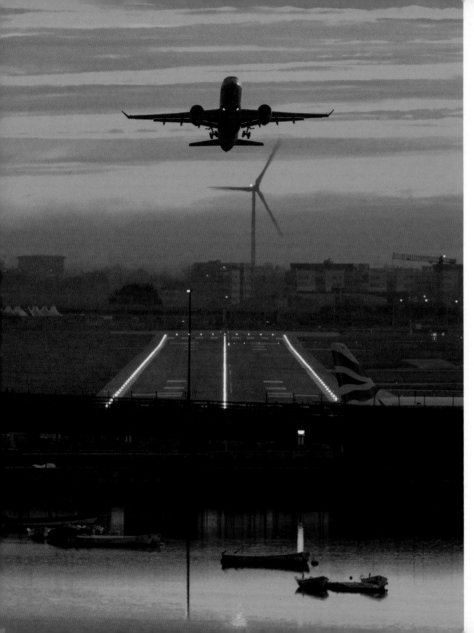

London City Airport

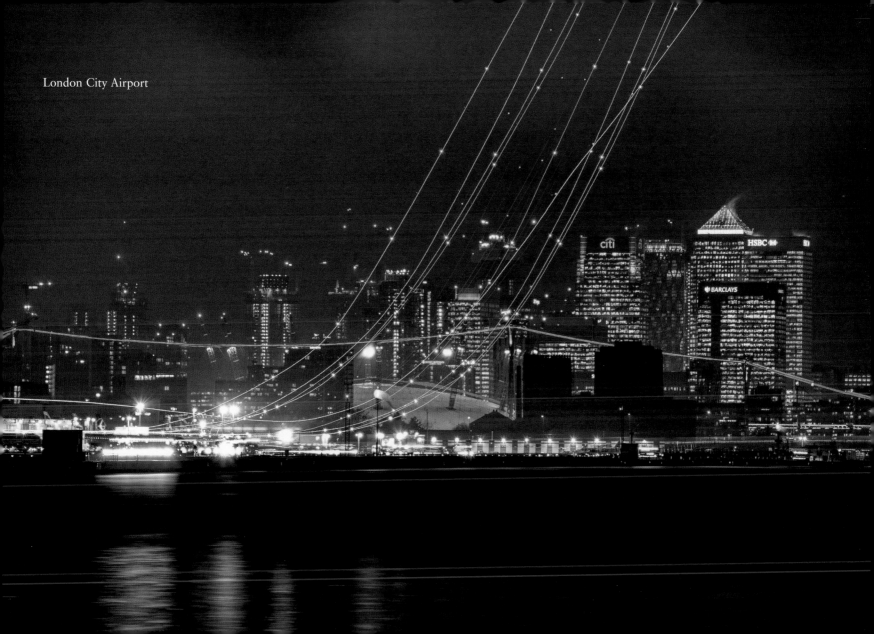

London City Airport

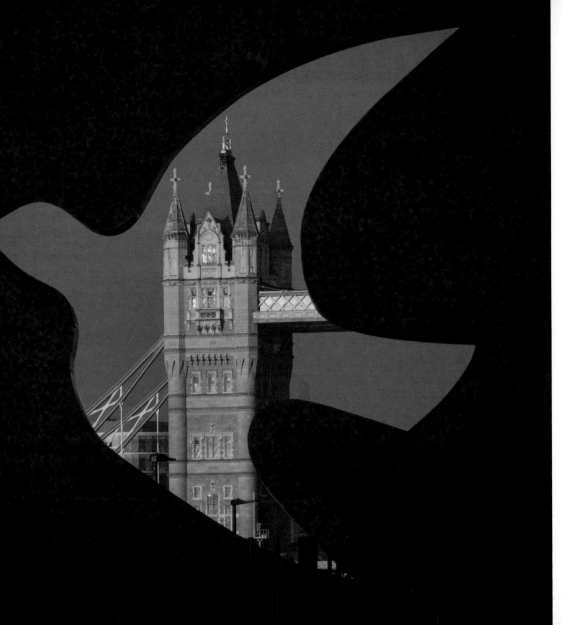

'Dove of Peace', Hermitage Wharf
Memorial Garden

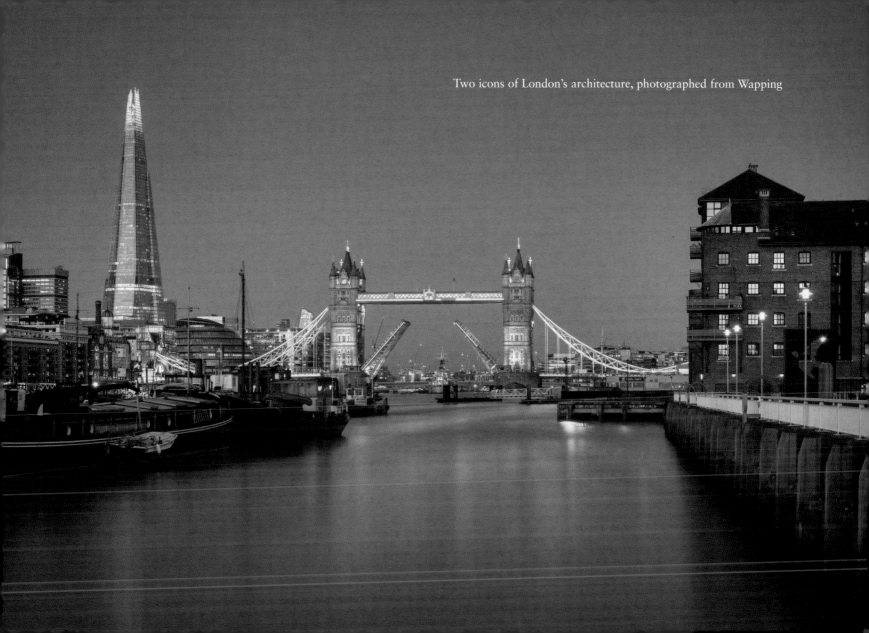

Two icons of London's architecture, photographed from Wapping

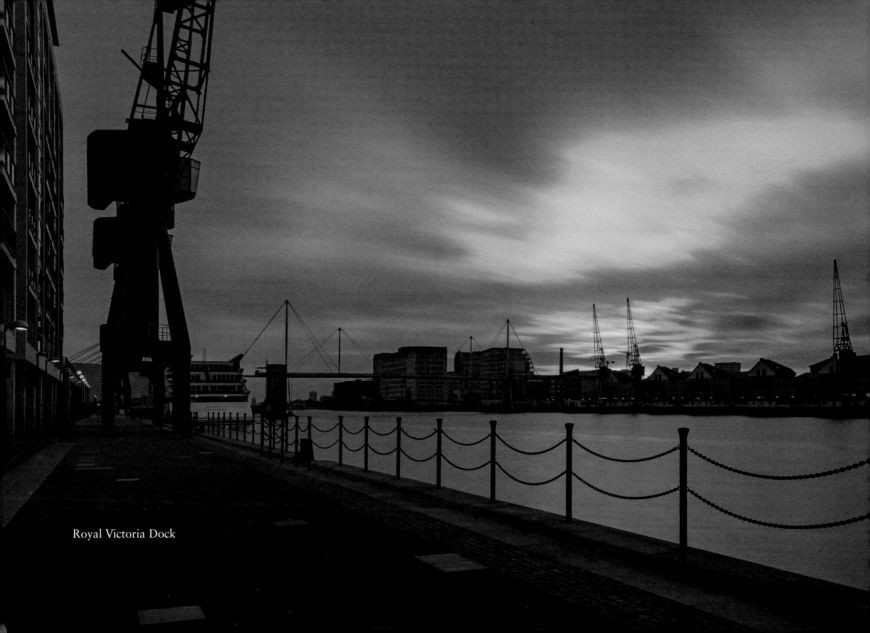

Royal Victoria Dock

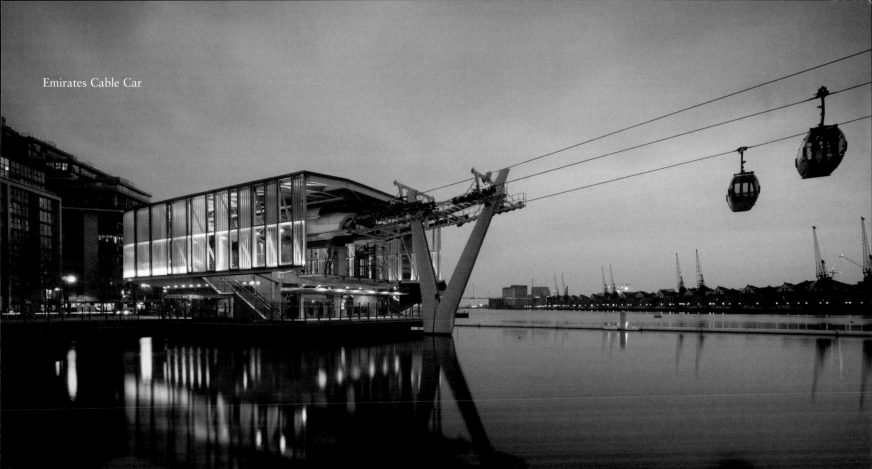

Emirates Cable Car

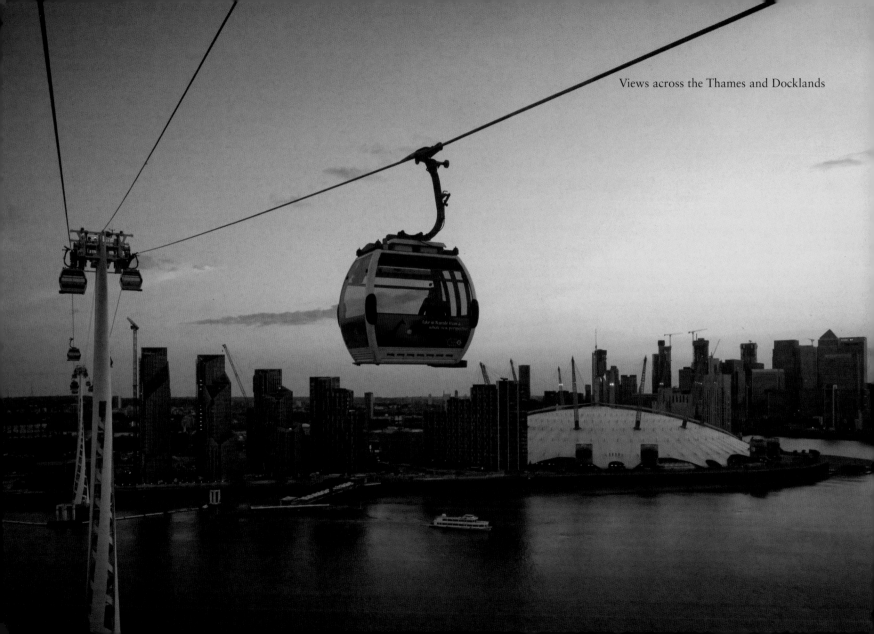

Views across the Thames and Docklands

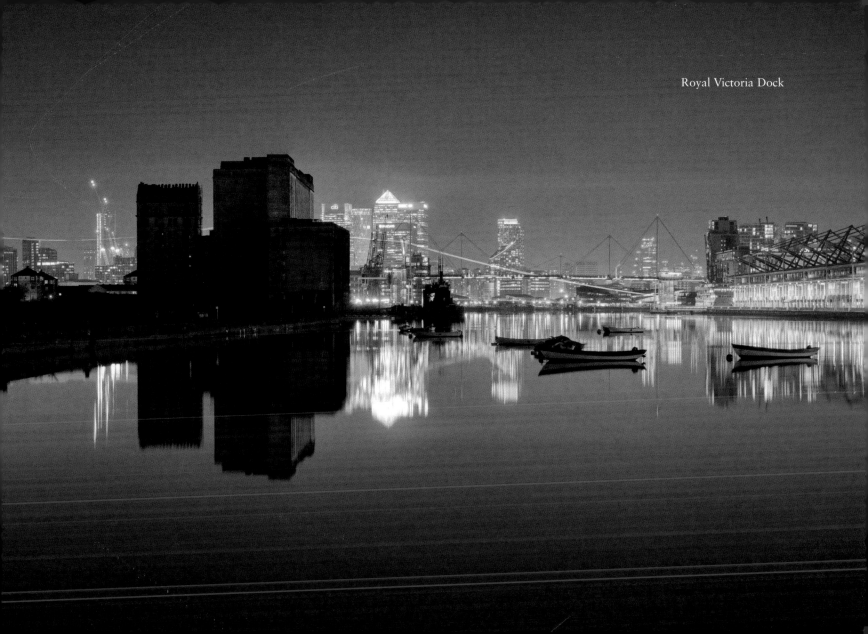

Royal Victoria Dock

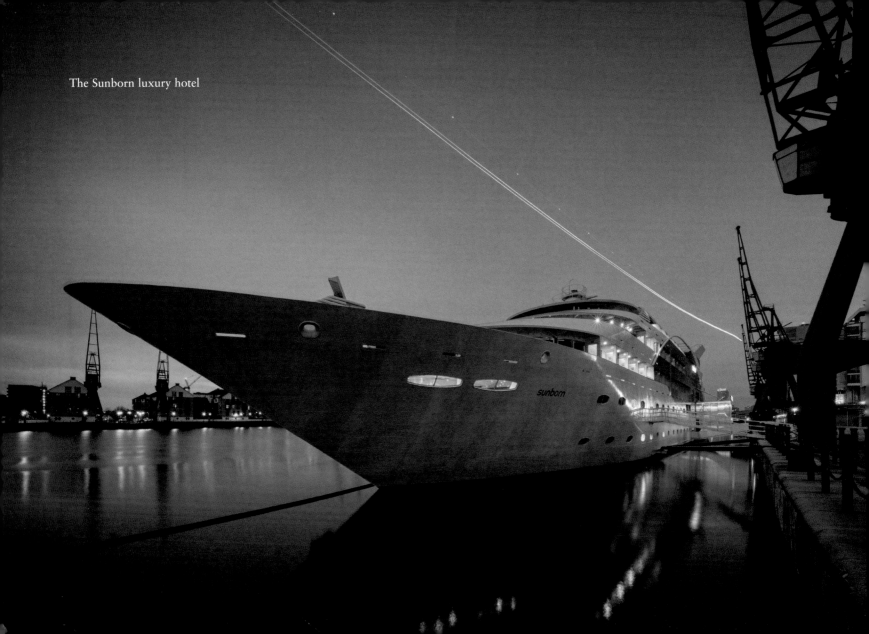

The Sunborn luxury hotel

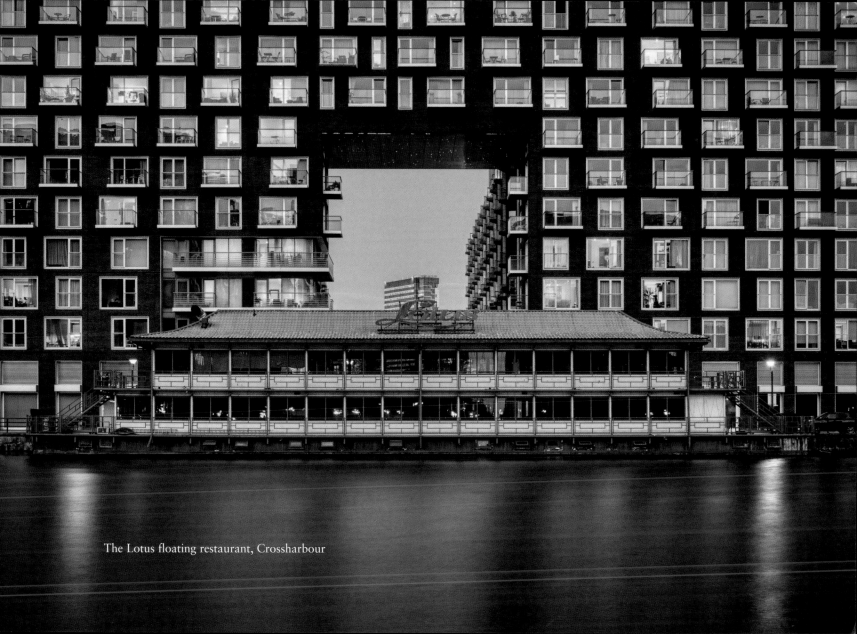

The Lotus floating restaurant, Crossharbour

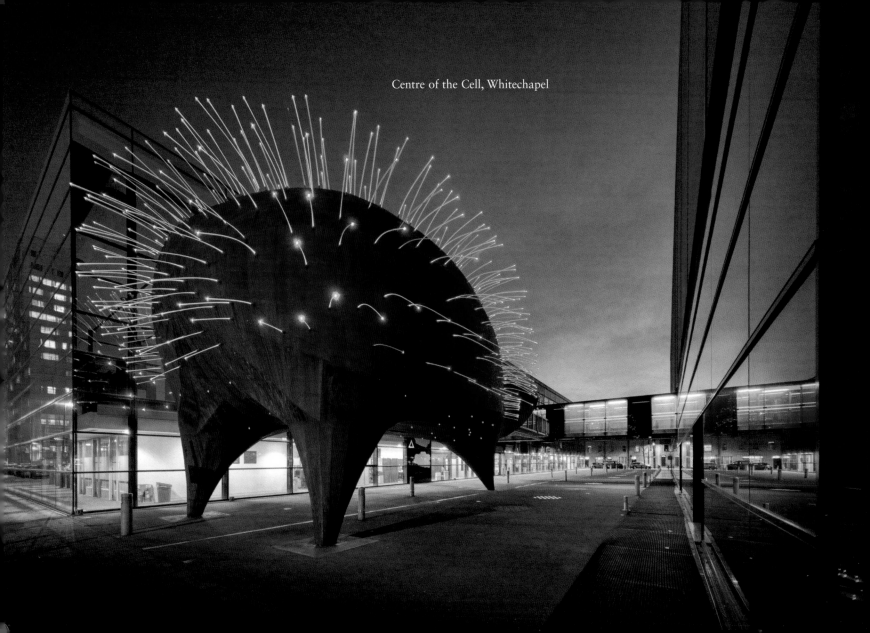

Centre of the Cell, Whitechapel

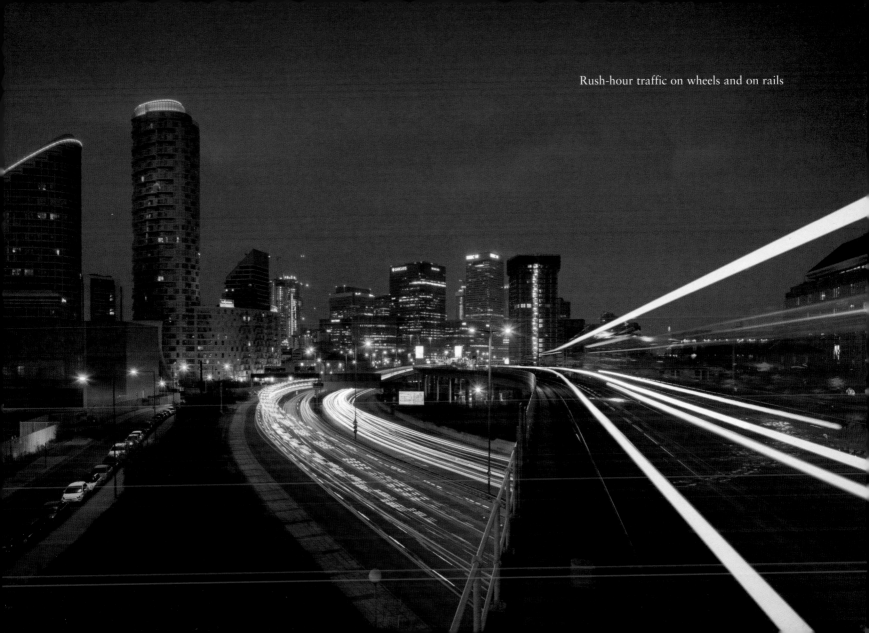

Rush-hour traffic on wheels and on rails

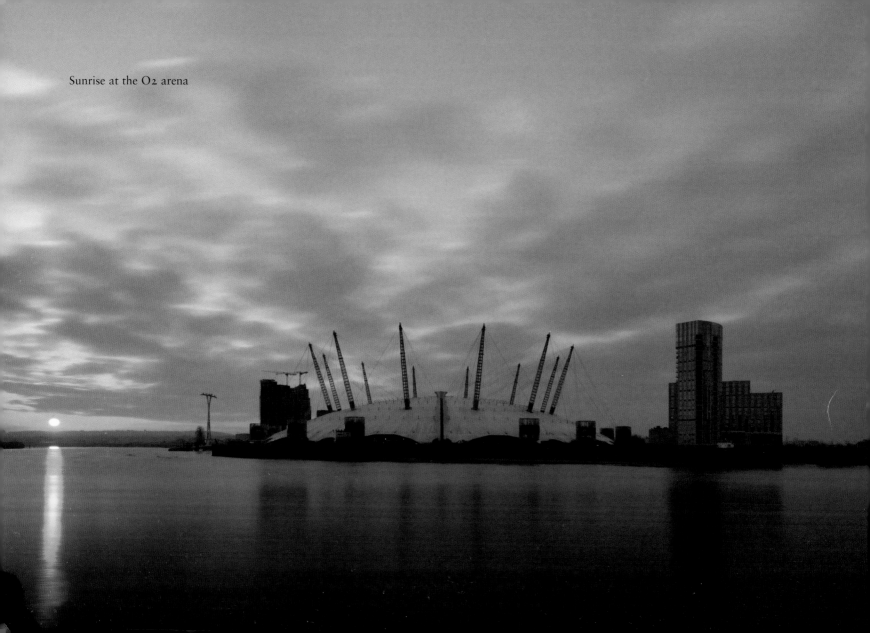

Sunrise at the O2 arena